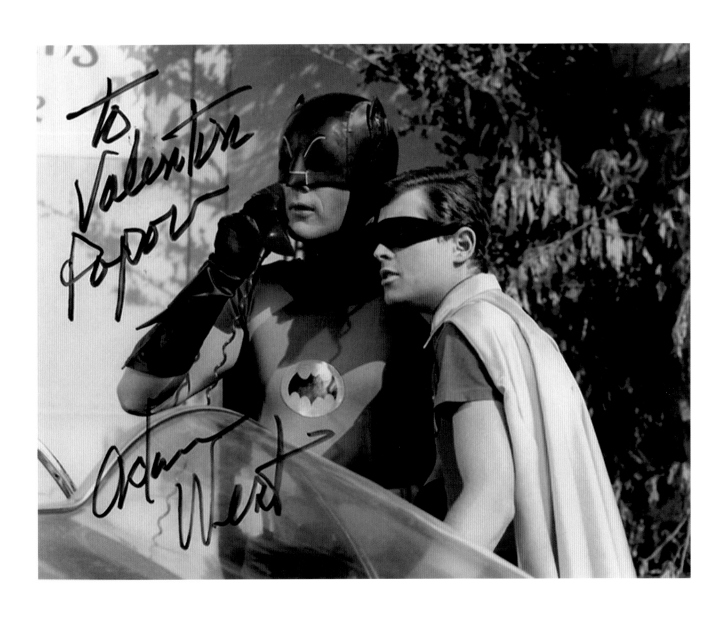

1

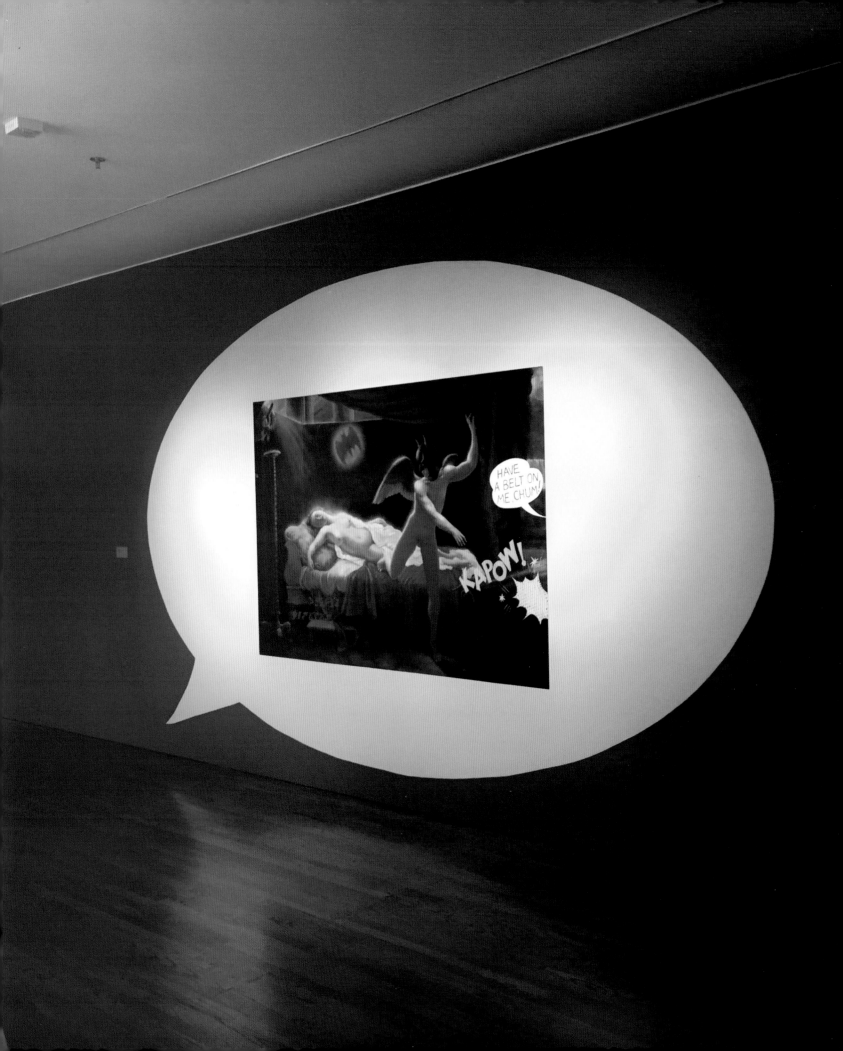

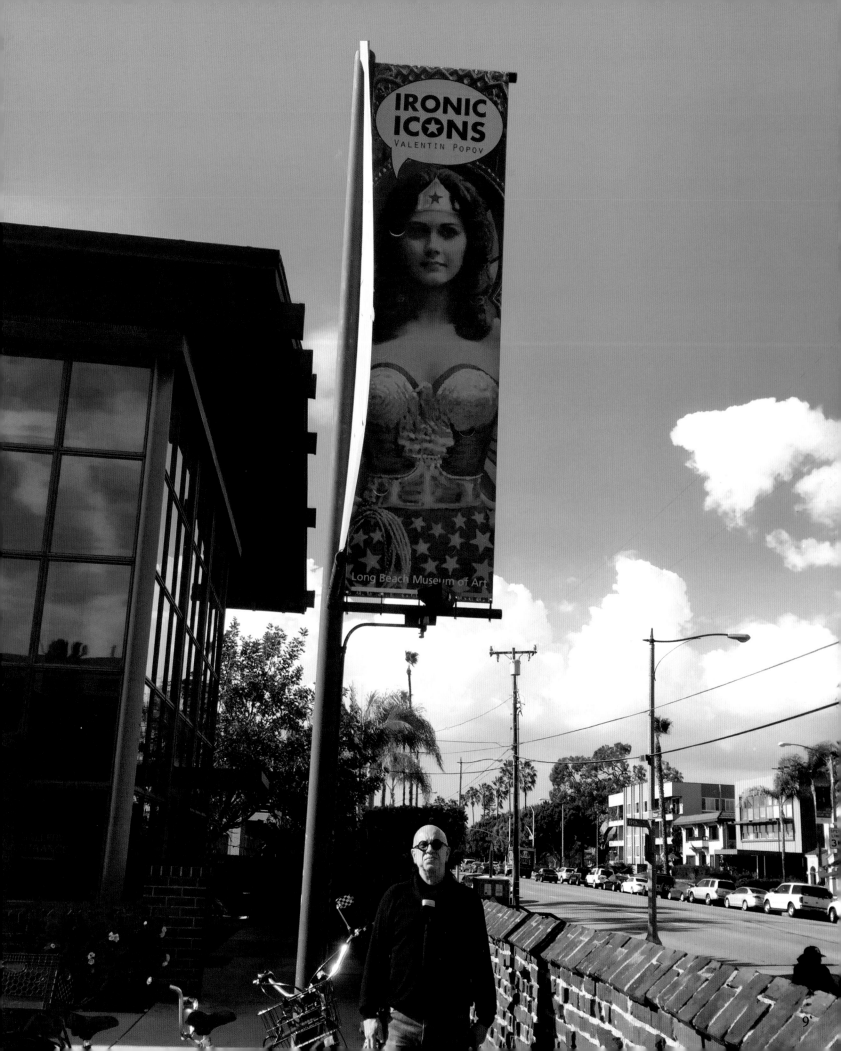

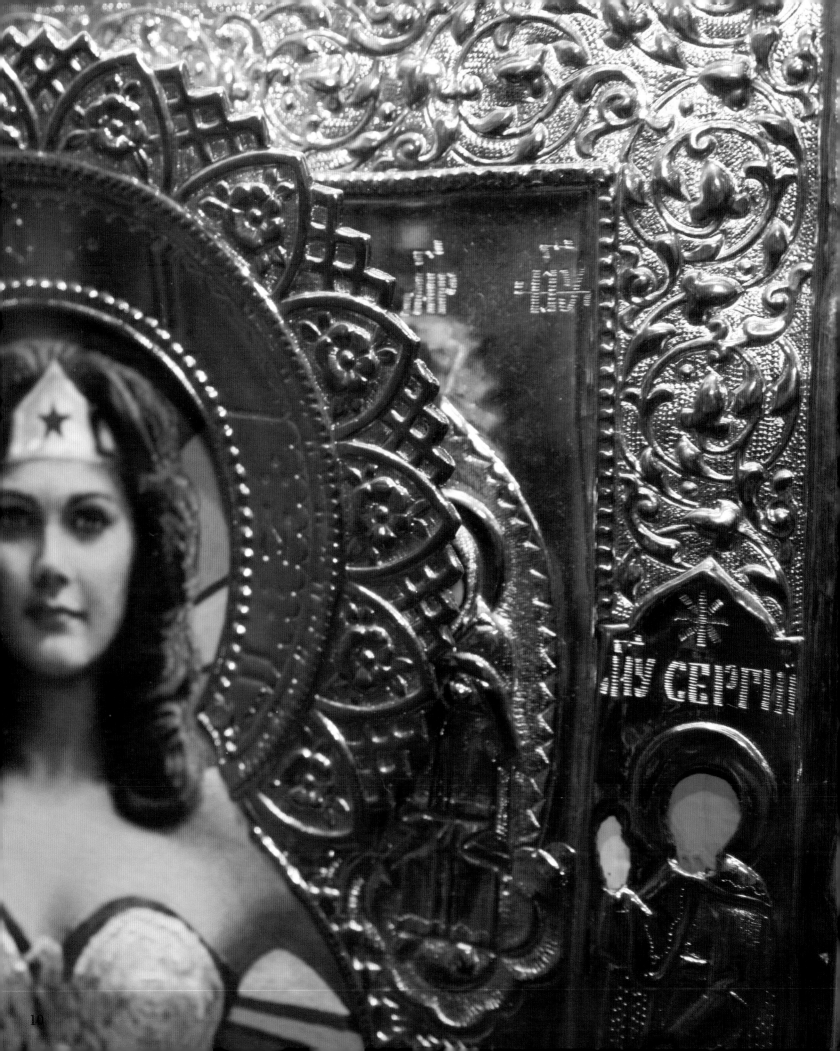

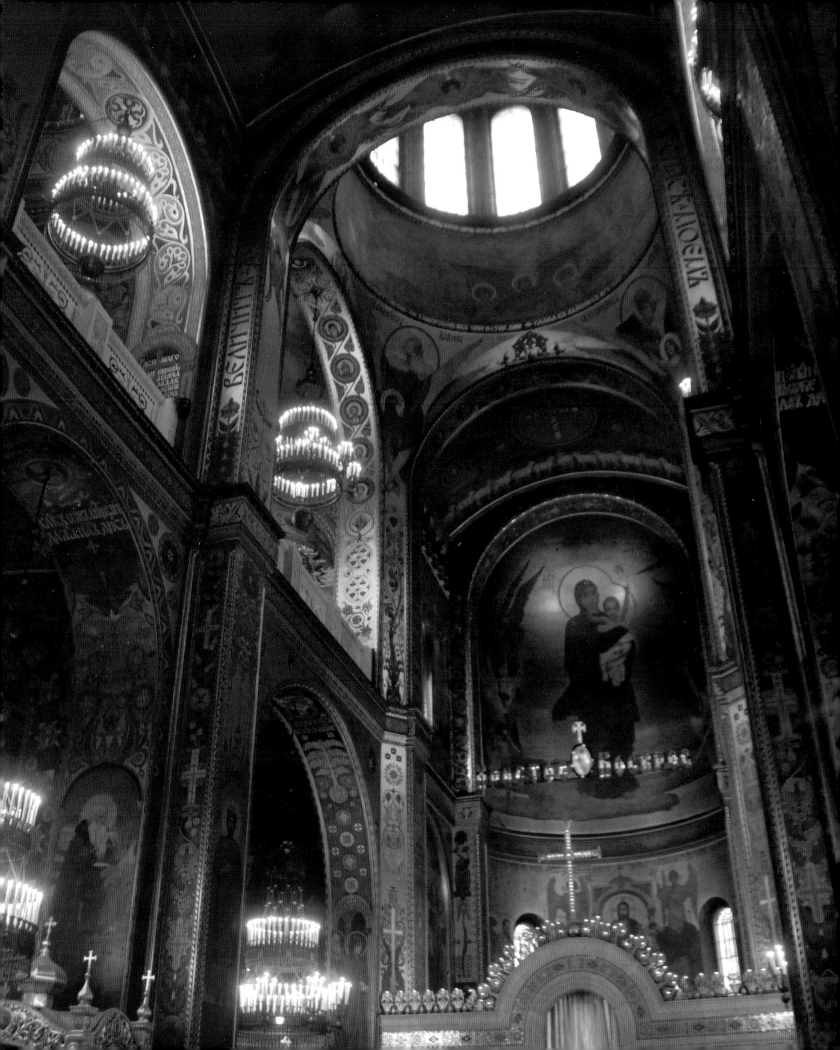

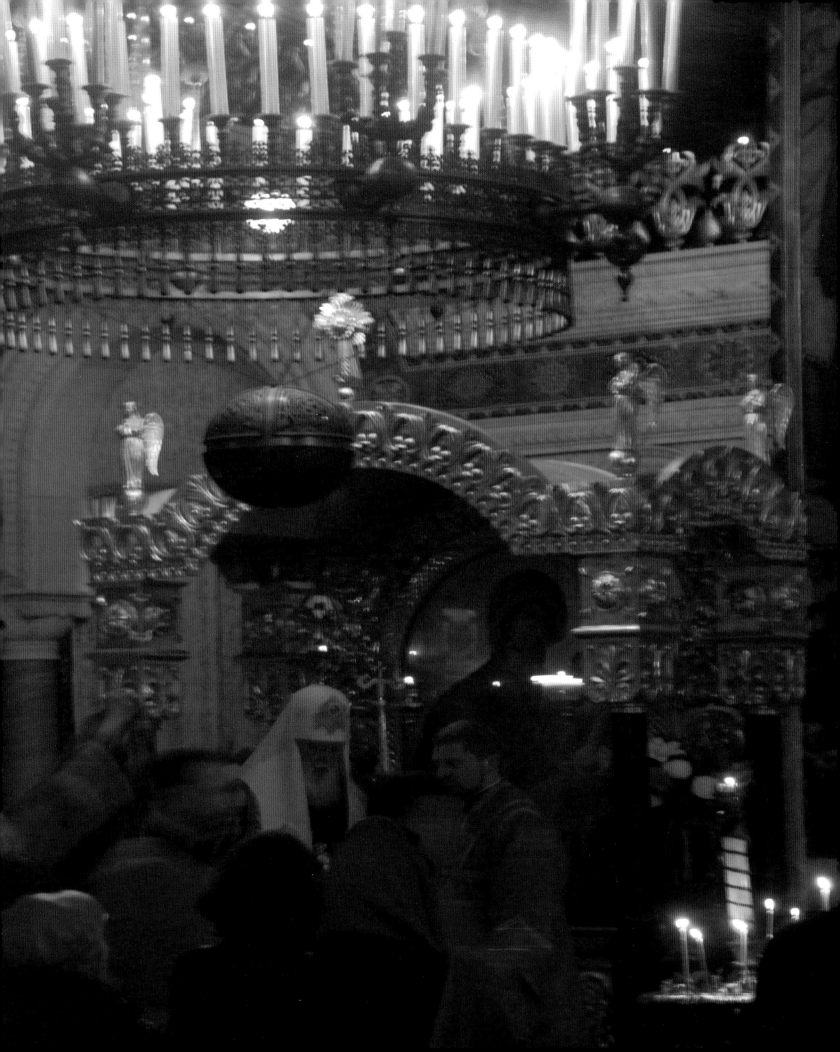

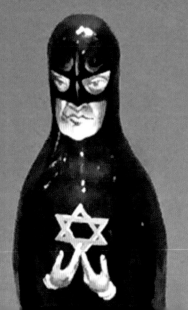
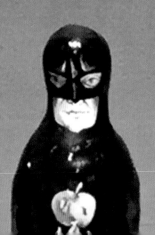

18

IRONIC
IC★NS

Ironic Icons
Contact: saintbat@aol.com

ISBN# 9780997148688 Case bound Edition
First Printing July, 2020
Book Copyright © 2020 Valentin Popov

Book Design: Blue Trimarchi, Los Angeles, CA

Printed and bound in China

Acknowledgments

Without the help and support of many people this book would not be possible

The Long Beach Museum of Art
Ron Nelson the director of the Long Beach Museum of Art
Amy Chung
Kit Wertheimer
Kevin W. McNeely and Rosemary McNeely
Director Rebecca Schapp of the De Saisset Museum
Dale Djerassi
Alex Gatti
Maureen and Pierre-Yann Guidetti founders of Savoir Faire
The Sonoma Valley Museum of Art
Linda Keaton Director of The Sonoma Valley Museum of Art
Rick Gilbert
Blue Trimarchi
The South Pasadena Arts Council
Petr Markman & photomodus
Shyshlovskyi Serhii
Andrei Ustinov
Charles W Hendricks Hope & Grace Wines
Jon Witkin

SOUTH
PASADENA
ARTS
COUNCIL

IGNITING CREATIVITY,
ILLUMINATING THE ARTS

Thank you for your generous support!

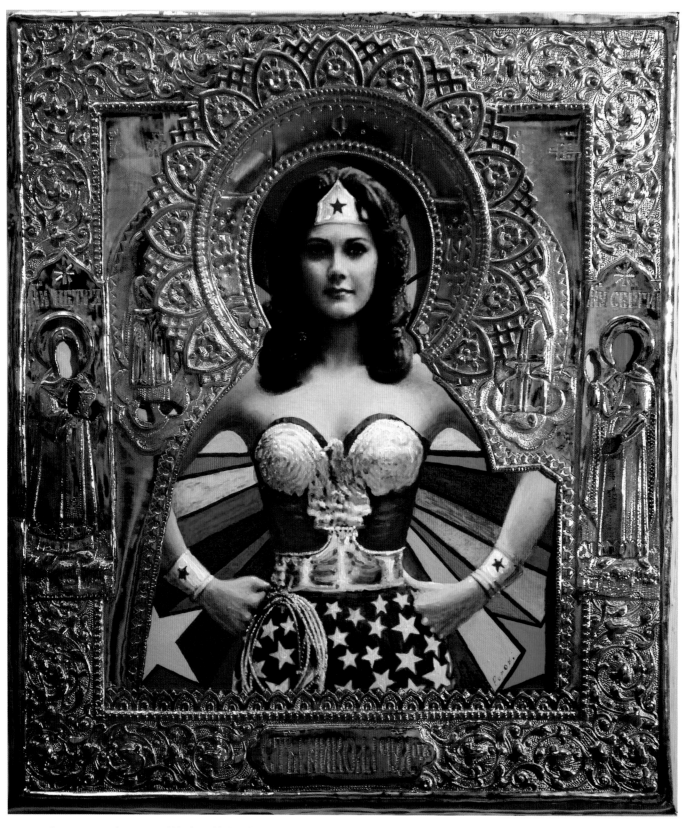

"St. Wonder Woman" oil on a wood block, gold plated 19-th century oclad 13.5"x12" 2009

TABLE OF CONTENTS

Preface *by Valentin Popov* 29

Ironic Icons *by Dr. Claudia Bohn-Spector* 35

Note From the Director *by Ron Nelson* 38

Coming To The Rescue *by Robert Flynn Johnson* 42

Essay *by Victor Sydorenko* 47

Essay *by Dale Djerassi* 51

Letter *by Valentin Popov* 57

Words *by Alessandro Gatti* 59

Mockery Squared: Paradoxical Parody in the Art of Valentin Popov *by Rick Gilbert* 61

Sleight of Hand, Sly of Eye: The Postmodernist Prerogative *by Rick Gilbert* 65

Romantic Cynicism *by Rick Gilbert* 87

St. Batman *by Rick Gilbert* 113

An Ironic World View *by Amy Chung* 116

Ironic Irony *by Andrei Ustinov* 120

Conceptual Collaboration *by Robert Flynn Johnson* 128

Batmen in the Belltower: Art as Secular Religion *by Rick Gilbert* 138

Valentin Popov 155

Bio and Exhibitions 166

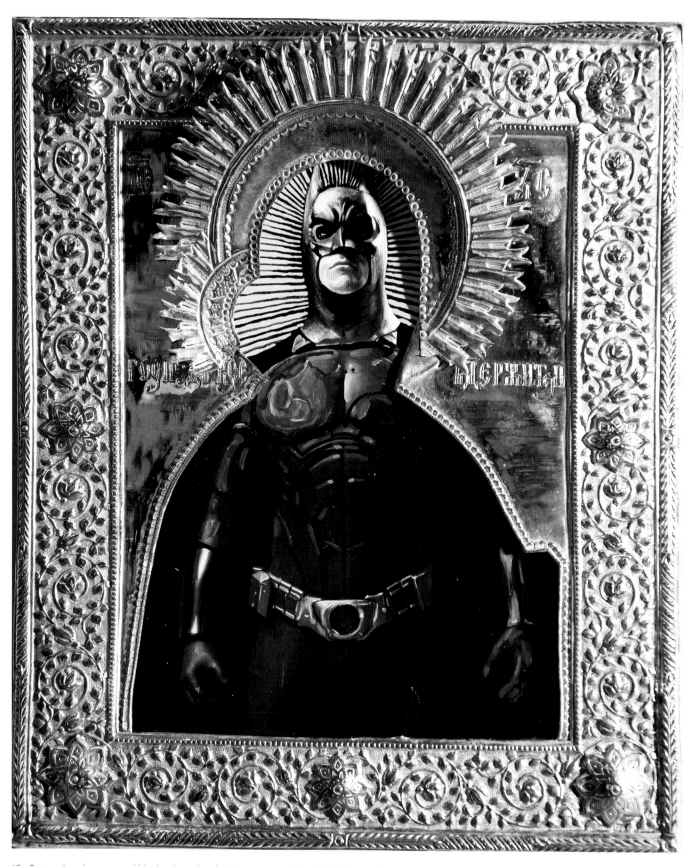

"St. Batman" oil on a wood block, silver plated 19-th century oclad 12"x10" 2016

PREFACE

The icon has a long tradition in Eastern Orthodox Christianity with examples traced back to the sixth century. Rejecting the Old Testament prohibition of making graven images, the icon being not three dimensional, developed as a flat panel painting, often with elaborate surface carving or metal embellishments. Unlike western Christian painting that emphasized narrative and explored a wide range of Biblical subjects, icons are fairly static depictions of holy beings or objects such as Christ, Mary, saints, angels, the Lamb of God, or the Cross. Less common are narrative scenes such as St. George and the Dragon or a holy portrait with scenes from that individual's life depicted around the borders of the work. Icons appear to be simply another form of panel painting to western eyes but they are mistaken in that impression. I should know, as having been born and raised in the Ukraine, that icons are an integral visible and spiritual element of daily life in Eastern Europe and a mystical manifestation of the Holy Spirit.

An icon is not merely a picture. Its significance is hard to describe to the uninitiated. The word that best describes a believer's response to icons is veneration… a combination of awe and respect. In addition to being an object of contemplation, an icon, whether Christ, Mary, or some other image, functions as a symbolic vehicle of salvation for a believer.

Arriving in this country as a young artist, I was struck by the constant verbal references to Christianity by ministers, politicians, and commentators, just like there are today, but by a near complete absence of visual imagery in the daily life of average Americans. What also struck me here, however, was the predominance and popularity of superheroes through movies, television, books, and comics. Visually stunning with colorful capes and masks, some endowed with super powers, others with exotic and ingenious weapons, devices, and vehicles, these heroes lived not just in the imagination of young people but occupied a prominent position in the consciousness of adults. As Andy Warhol had transformed and elevated images of Marilyn, Liz, Jackie, and Elvis into substitutes for Jesus and Mary in high art, comic book superheroes functioned in a similar fashion in broad popular culture. Like the teachings of Christianity, the actions of these fictitious superheroes emphasized selflessness and coming to the aid of the oppressed, endangered, and downtrodden.

It was in 1993 that I first began to meld my Ukrainian past, filled with the memories of icons, with the exciting yet unnerving sea of popular culture I was now swimming in here in America. I focused upon the image of Batman over all other superheroes. Poignantly, he was, more than any of the others, just a man. He was not endowed with any super powers beyond his intelligence, athleticism, and an exotic array of weapons, devices, and vehicles at his disposal. This sense of power mixed with human vulnerability made him an irresistible choice to incorporate into my art. Over an intense two-year period, from 1993 to 1994, I explored the myth of Batman in painting, collage, sculpture, performance art, and photography. During this period, I briefly experimented with the notion of utilizing the icon form in several 1993 works (Batman Icon and Batman Icon (St. George) but never fully analyzed or understood the full potential of what the form, materials, and spiritual significance of the icon could be in informing my own art…until now.

Barnaby Conrad III wrote about me that I had, "the skill of an academic master and the satirical eye of a postmodern comedian." I don't know if that is true, but unlike many artists today, I seek to know and understand the past in order to intelligently face the future.

-- Valentin Popov

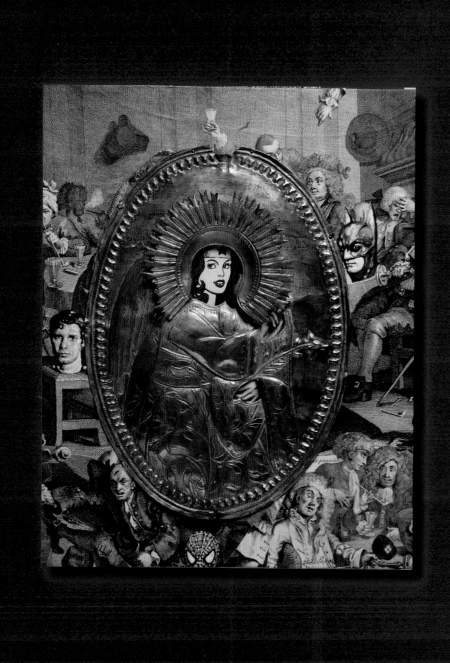

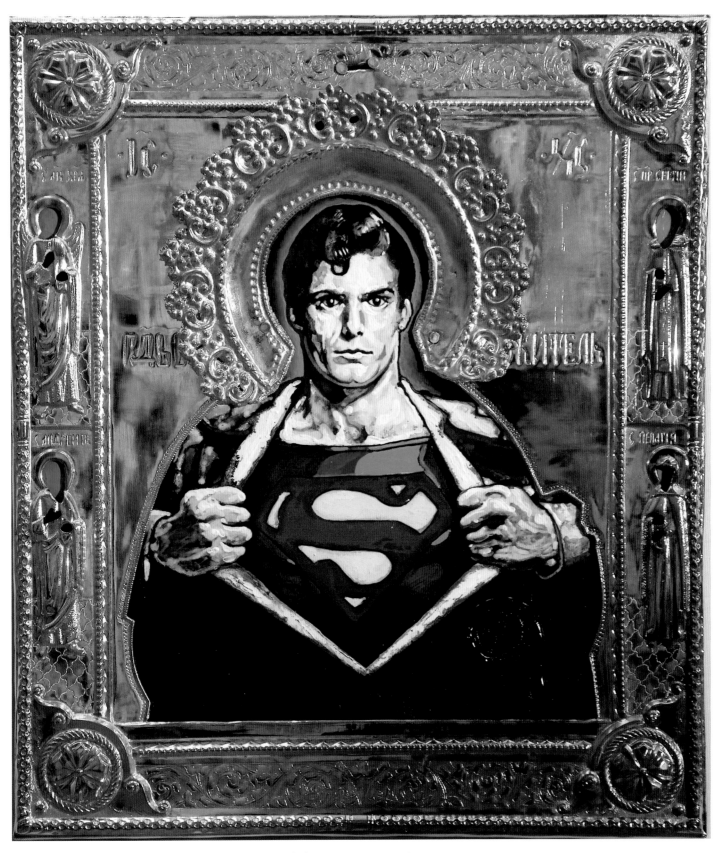

"St.Superman" oil on a wood block, gold plated 19-th century oclad 13.5"x12" 2009

"St. Batman", oil on aluminum, 90"x86", 1994

32

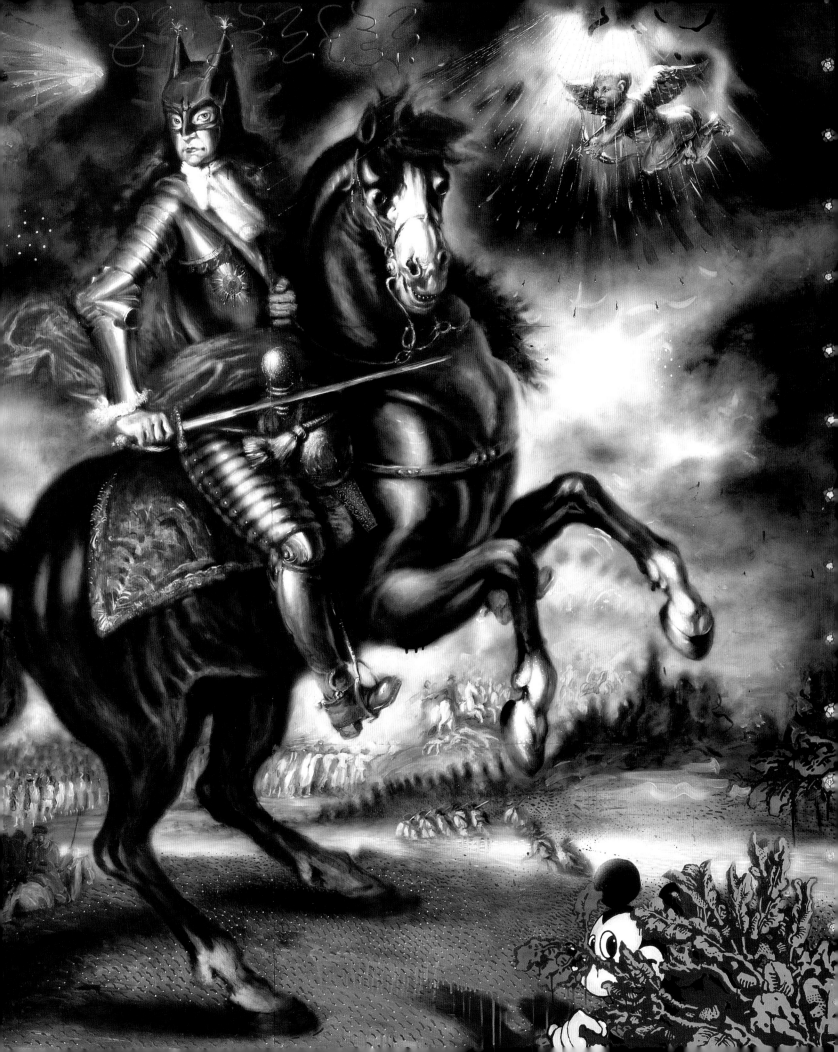

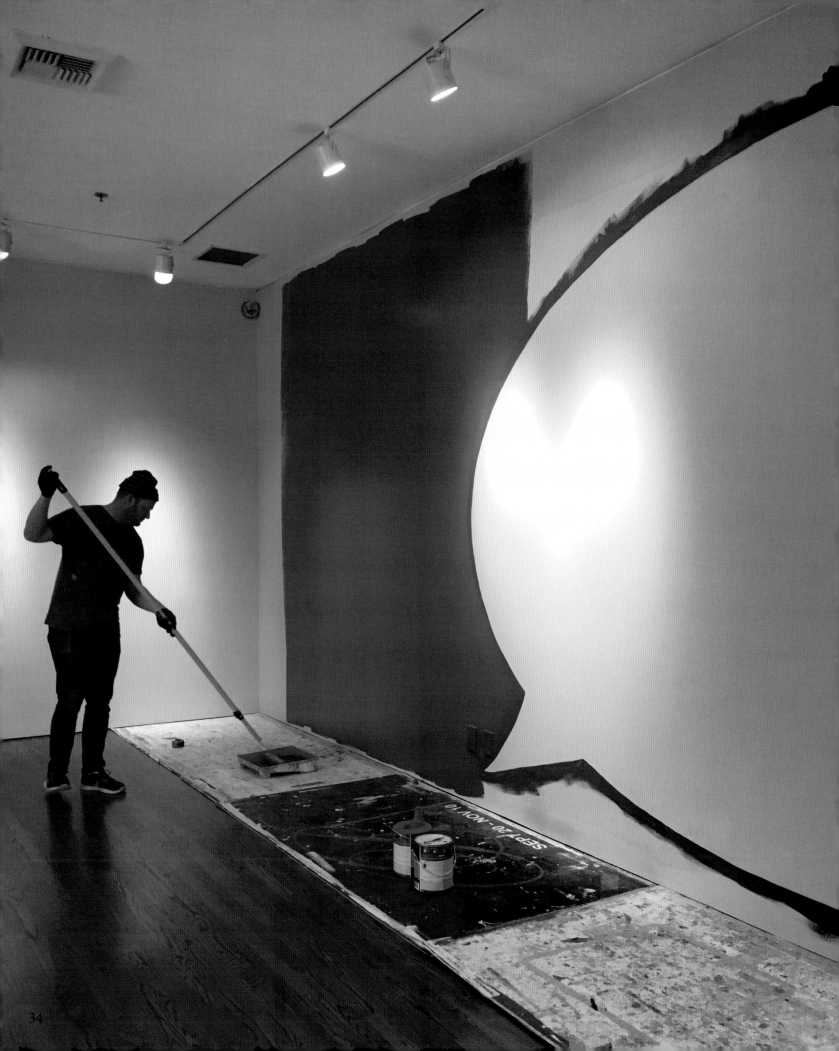

SEPT 20 - NOV 16

34

Ironic Icons: *The Art of Valentin Popov*

"Irony is a disciplinarian feared only by those who do not know it, but cherished by those who do," the 19th century Danish philosopher Søren Kierkegaard once famously wrote. Unlike humor, which opens the mind with hilarity and kindness, irony seeks a deeper, less comfortable understanding. Derived from the ancient Greek word eironeía, or "feigned ignorance," it represents a mockery, a sophisticated challenge and subversion of what is ostensibly expressed. At once comical and bitter, sharp-witted and swift, irony rarely works to reassure the viewer, propelling us instead toward the realization of a darker, hidden truth.

Ukrainian-born artist Valentin Popov leans heavily on irony, satire, humor, and comedy to convey his artistic message. Born the son of one of Kiev's most preeminent artists, he was formally trained at the Academy of Fine Art of Ukraine and at the Kiev State School of Art. An all-around talent equally adept at printmaking, drawing, painting, collage, sculpture and installation, Popov frequently mixes media and genres, blending academic art with tongue-in-cheek commentary rooted in popular culture. His iconic large-scale painting Early Morning, for example, is based on the 1817 canvas L'Amour et Psyché by the neo-classical French painter François-Édouard Picot. Painted on aluminum, it shows the mythological god of love and desire, disguised as Batman, leaving the bed of his lover after a tryst. In other works, Popov embeds comic strip heroes in traditional Russian icons, contemplative art works long associated with Eastern Orthodox Christianity. In lieu of the holy figures typically seen in such paintings—Christ, the Virgin Mary, the saints, angels, the Lamb of God, or the Holy Cross—we encounter Superman, Wonder Woman, Mickey Mouse, and Batman with their colorful retinue of masked helpers and handmaidens. Commercial logos, too, are seen against an icon's gem-encrusted sterling and gold cover, blurring the line between the sacred and the profane and pointing to the fictional character of both the image and the figures depicted.

Of all American superheroes and heroines, Valentin Popov clearly favors Batman, who, for a series of works in this book, has become his creative alter ego and avatar. "Poignantly, he was, more than any of the others, just a man," the artist explains. "He was not endowed with any super powers beyond his intelligence, athleticism, and an exotic array of weapons, devices, and vehicles at his disposal. This sense of power mixed with human vulnerability made him an irresistible choice to incorporate into my art." In Popov's thought-provoking work, the mysterious Dark Knight and Caped Crusader becomes the ultimate stand-in for the contemporary artist him- or herself, a truth teller and dispenser of irony in an age where meaning is perpetually in flux.

Dr. Claudia Bohn-Spector
Chief Curator
Long Beach Museum of Art

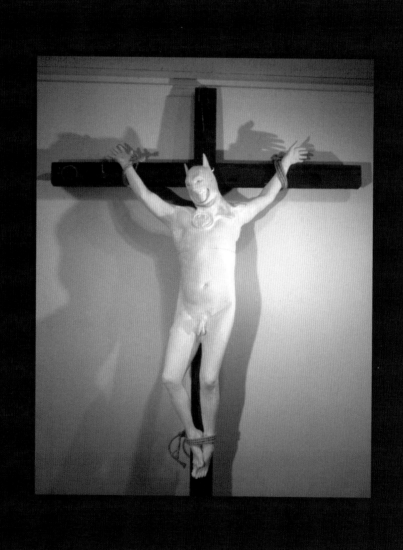

A Note from the Director

During the course of my curatorial career, it has been my privilege to travel extensively and to survey a wide array of trends and tendencies in visual arts production around the world. In today's global village, the art scene has become increasingly cosmopolitan and a plethora of culturally diverse and startlingly progressive work is emerging everywhere, unpredictably and in surprising places. Yet how much more unexpected it is to discover a major creative talent of distantly foreign origin here in our own backyard!

Ukrainian born and classically trained multi-media artist Valentin Popov is a transplant from Kiev to California where he populates his bustling studio with a never-ending stream of edgy portraits, allegorical narratives, moody, dream-fueled landscapes, pop surrealist confections and Renaissance-inflected collages. A master of technique, equally at home in a variety of media, genres and styles, Popov can paint a veristic portrait, a Rembrandt etching look-alike, or a fantastic, fabulistic canvas worthy of Dali or Ernst; his sculpture is reminiscent of De Stijl and the Russian Constructivists. He can deftly simulate the flavor and features of aesthetic methods ranging from Mannerism to Pointillism. His execution is marked by subtlety, sensitivity, and phenomenal attention to innate detail that arises intuitively.

Popov is a postmodernist, thriving on the vast panorama of art history and its proud pageant of myriad movements and schools. Popov has leveraged the liberty inherent in this artistic approach by blending imagery derived from disparate sources in a seamless fusion. His artistic ability is such that he is able to mesh visual elements that would ordinarily clash and collide, in a sort of reverse osmosis. Popov's Ironic Icons involve a specific set of ingredients: antique imagery excerpted from traditional religious visual aids common for centuries throughout Russia and imagery lifted from cartoons and comic books of the present-day western hemisphere. Popov juxtaposes these otherwise mutually exclusive constituents in such fashion that they serve as characters of a modern mythology of his own creation. Popov slyly unites high culture with low, elite with popular, Old World tradition with New World vulgarity and, in the process, grants the same credence and validity to Mickey Mouse and Superman as to the saints and martyrs of the Eastern Orthodox Church. Also worth noting is the meta-art aspect of Popov's oeuvre – the production of art about art with all its internal allusions and inherent self-references.

It has been said that after a hundred years of experiment and innovation, the cultural avant-garde quietly faded away, and the truth of this assertion is all but indisputable. After the initial frenzy of the late nineteenth century and continuing throughout most of the twentieth, a dazzling series of artistic experiments overran the cultural landscape. Little in the way of groundbreaking new movements or trailblazing originality has emerged in the twenty-first century, but here and there a spark of inspiration ignites and gives birth to fresh attitudes and perspectives. With the advent of Postmodernism, artistic compositions combining an amalgam of elements borrowed from miscellaneous historical periods emerged as a novel initiative.

As in the science of heredity, art exhibits traits and characteristics indicative of its lineage. Art has its purebreds, its hybrids and, occasionally, a mutant strain that defies the natural order. With his St. Batman series and now, with his ironic icons, Popov has forged a brand of satire very much in the tradition of Gogol and bearing the same Russian sensibility, but distinctly his own and fully contemporary, to which he coyly refers as Romantic Cynicism. With the impishness of a prankster, Popov is one of those rare birds who not only has created a new nomenclature, but a new semiotics, a new "forest of signs" suitable for the postmodern era and, in the process, has expanded the vocabulary of visual aesthetics.

Art of the highest order is defined by the presence of one or more important components: style, originality, concept, technique. Rarely, art possesses these components in unison. In the case of Popov, we see the presence of all of these components in unanimous agreement – and the result is a synergy greater than the sum of its parts. Popov's masterful synthesis of satirical wit, superb technique, and flawless execution is what makes his art exceptional and unique and ensures its enduring value and significance.

When all is said and done, the exhilarating remains are art's infinite capacity to re-invent itself. Valentin Popov's ironic icons perfectly embody this principle.

Ron Nelson
Executive Director
Long Beach Museum of Art

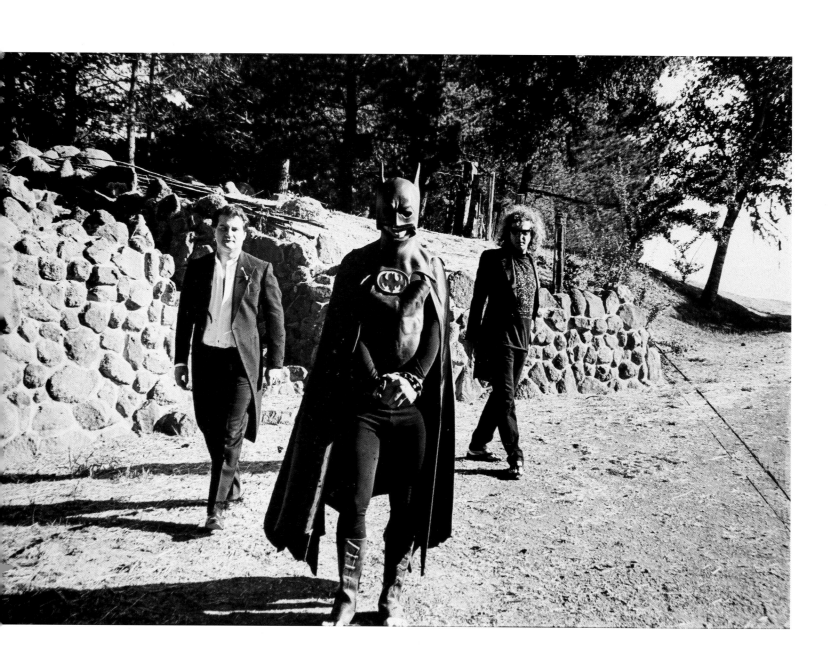

"St Batman Crucifiction" Valentin Popov and David Perry collaboration, split toned with Kodak sepia toner 8.75"x 12.5" edition 20 1994

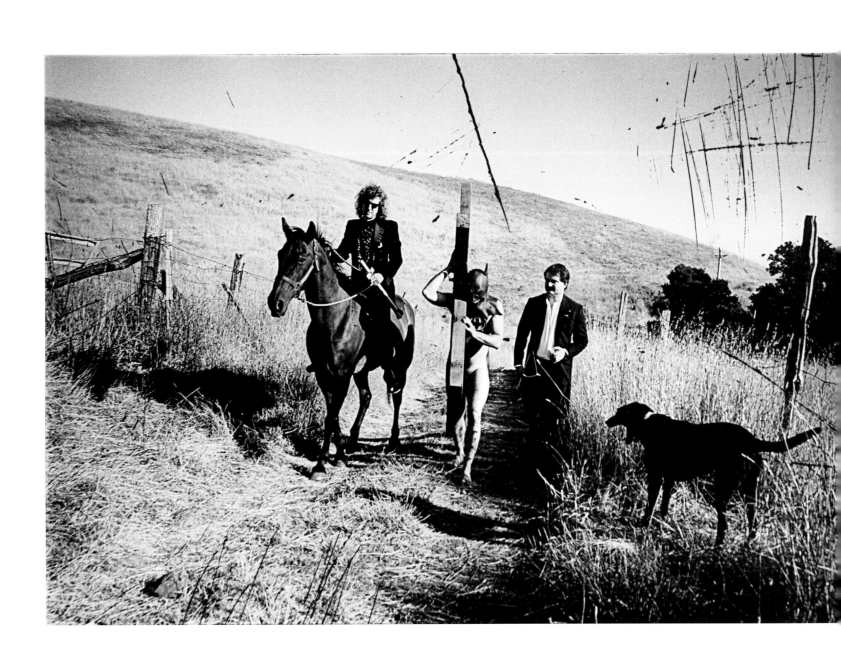

"St Batman Crucifiction" Valentin Popov and David Perry collaboration, split toned with Kodak sepia toner 8.75"x 12.5" edition 20 1994

Coming To The Rescue

After World War II the tear glands of the world dried up from over-use. It is this world for which Warhol is spokesman.[1]

—Lucy R. Lippard, *Pop Art* (1966)

We live in a world of intense but transitory visual and mental stimulation. Attention Deficit Disorder that was once a medical condition of the few is liable to become a defining trait of a whole generation of individuals. The advent of the computer and smartphone, with their ability to access a multitude of "social media," has compounded our inability to reflect upon images or ponder ideas.

A decade ago, it was said that there were more smartphone photographs taken in a week than in the whole nineteenth century. Undoubtedly, today there are more photographs taken in just a single hour. However, those nineteenth century photographs were given an attention completely at odds with how photography is treated today. At that time, if they were of loved ones or family members they were treasured, and were marveled at if they recorded distant and exotic places. For them, the photograph magically stopped time.

Today the torrent of photographic images we accumulate are only of short-lived interest, to be deleted or more likely poured into a "cloud" with the vague notion of editing and retention that rarely occurs. We are slaves of the shiny current moment at the expense of learning from the past by reflecting upon history, science, art, society, customs, and religion.

We live in an increasingly secular society. Religion is still a fundamental aspect of many people's lives but its accompanying devotional religious imagery is not. The individual who fortuitously recognized this phenomenon and incorporated it into his art was Andy Warhol. A quietly fervent member of the Byzantine Catholic church, Warhol was also a fanatical reader of movie magazines in his youth. In his early days as a Pop artist in the 1960's, Warhol conflated these two passions into one, capturing the zeitgeist of the era. He created a series of paintings featuring Marilyn Monroe and Jacqueline Kennedy, and to a lesser extent Elizabeth Taylor, Elvis Presley, and Marlon Brando. He portrayed them as quasi-religious alternatives in our modern age to the Virgin Mary and Jesus Christ.

If one were to ask people in the United States who are icons, they would probably say Beyoncé, Muhammad Ali, or Bruce Springsteen. However, if one were to ask the same question in Eastern Europe or Russia the answer among young people might be the same but amongst adults and the elderly it would be decidedly different. They instead would refer to icons as the long-standing tradition of painted panel representations of Christ, the Virgin Mary, St. George, and a variety of

other saints often but not always encased in gilded metal frames. The use of these ancient objects of religious devotion are treasured and prayed to for divine intervention.

This is the background from which the young Ukrainian artist, Valentin Popov, was nurtured. Arriving in America, Popov quickly absorbed the popular culture he encountered in this new liberated society. The genesis for the art in this exhibition came from Popov wisely recognizing the similarity of his memories of those seeking deliverance through prayer before the gilded religious icons of his youth with the fantasy rescuers from unfathomable dangers accomplished by the comic book heroes of the culture he was now living in.

In the earliest manifestations of his use of comic book characters, Popov usually portrays the image of Batman as a hero or puts him in a situation of deadpan irony. On one occasion, however, as in his photographic series of Batman's crucifixion, the hero has become an all too human victim. This series was an early example of Popov mixing religion and pop culture into his art.

In his most recent series of true Pop Art icons, Popov has come full circle in melding his two cultures together. A technically accomplished artist, Popov, in these paintings, adhered to working in the traditional icon method of utilizing wood panels. After outlining the composition upon the panels, they were sent to the Ukraine for artisans to apply gold or silver leaf to the areas Popov had indicated. Once the panels were returned to California, Popov would complete the intricately painted compositions.

Through extensive contacts in the Ukraine and Russia, Popov would direct individuals to seek out in flea markets discarded tin, brass or silver gilt icon frames called *oklad*, from which he could repurpose for his own "icons." Sadly, through religious persecution or neglect, these oklads had been removed over time from the painted icons they once housed. Popov never acquired an intact icon in order to extract its oklad.

In combining his super heroes into Pop Art vehicles of divine intervention, Popov has created art that both cleverly amuses but on reflection, raises questions concerning our sense of where do we turn to save ourselves in a dangerous world? Our divine yet invisible faith or the visible yet imaginary of our fantasies…or neither?

Robert Flynn Johnson
Curator Emeritus
Achenbach Foundation for Graphic Arts
Fine Arts Museums of San Francisco

[1] Ian Crofton, editor, *A Dictionary of Art Quotations*, New York: Schirmer Books (1989), pg. 194.

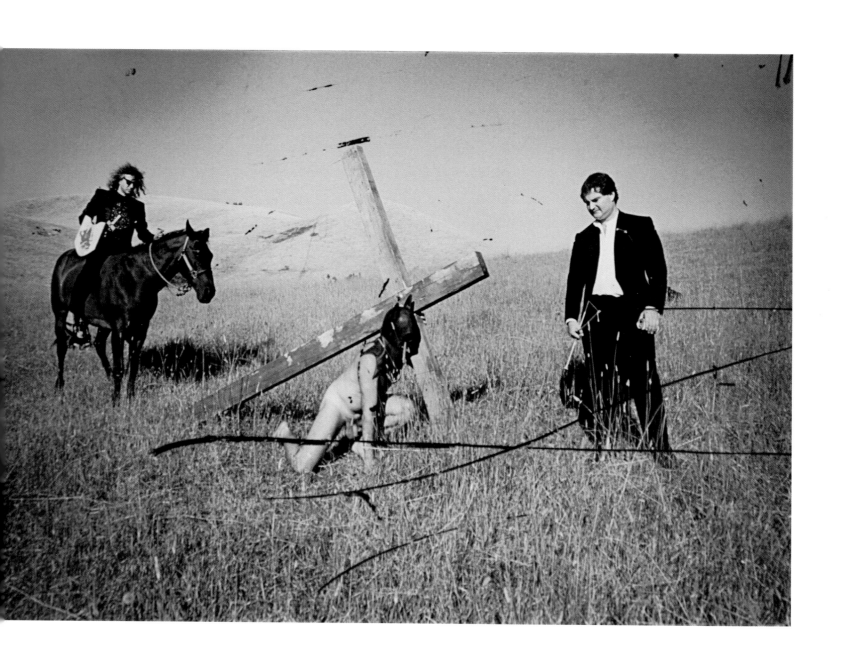

"St Batman Crucifiction" Valentin Popov and David Perry collaboration, split toned with Kodak sepia toner 8.75"x 12.5" edition 20 1994

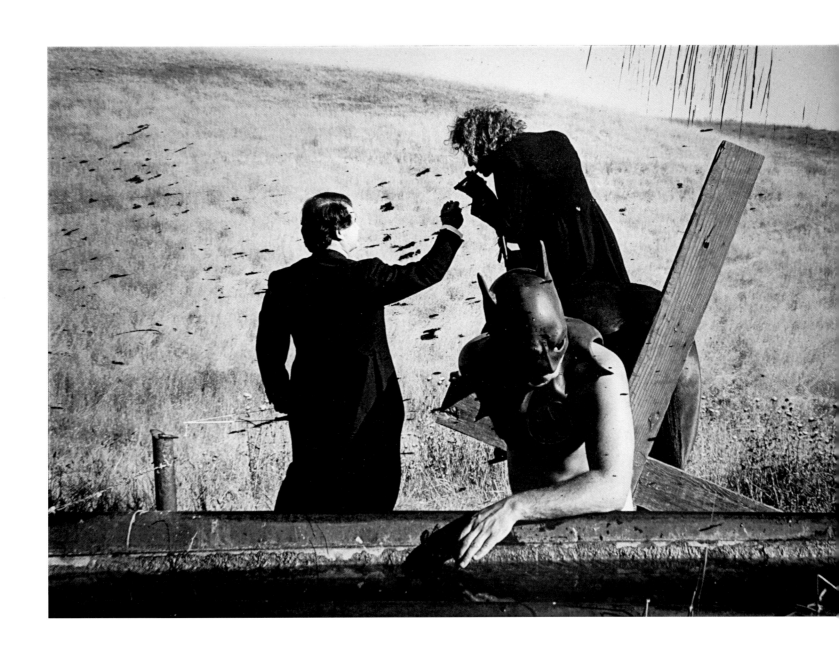

"St Batman Crucifiction" Valentin Popov and David Perry collaboration, split toned with Kodak sepia toner 8.75"x 12.5" edition 20 1994

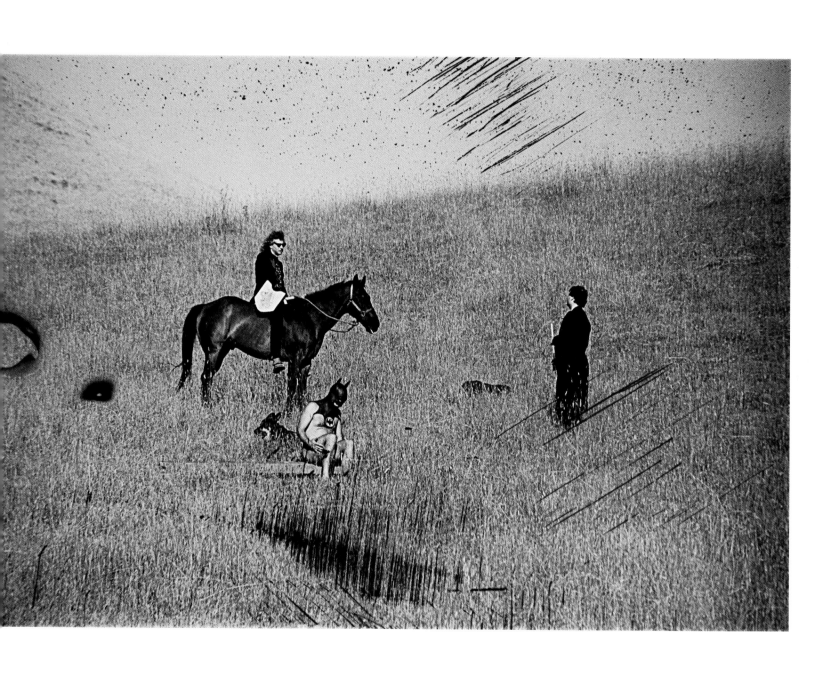

"St Batman Crucifiction" Valentin Popov and David Perry collaboration, split toned with Kodak sepia toner 8.75"x 12.5" edition 20 1994

The world is constantly changing. Every day, scientific progress opens new facets of knowledge and new aspects of reality, transforming man's apperception of the universe. However, from time immemorial, humanity has been distinguished not only by a capacity for sustaining a realistic understanding of the world, but by metaphysical speculation, which is a corollary of belief in the transcendental. The storied heroes of myth become a kind of "link" between what can be explained and the inexplicable. Technological progress is advancing with incredible speed, and each new epoch finds it necessary to update the heroic hierarchy of the cosmos: in harmony with the prevailing cultural climate, new heroes and new myths emerge and are vested with fresh significance.

Each generation constructs a certain human ideal, a type of "superhero" who is held up as an example of strength, morality, principle and social position. Pantheons of mythological and fabled beings have existed in all known cultures and exist in modernized form to this day, often embodying the image of a noble defender of humanity.

Modern man is unlikely to accord credence to the existence of mythological figures so, in the last century, such heroic beings have become characters endowed with extraordinary capabilities: Superman, Batman, Wonder Woman and many others – formed by the temper of their times and entrenched over succeeding generations and featuring their own unique visual features and moral attributes. These characters have become so famous and influential that they enjoy more "presence" in the public mind than real persons. They are instantly and universally recognizable and exert a powerful impact on the contemporary visual lexicon. Comic book pop culture is so widespread that it has become an integral part of everyday life.

Valentin Popov, a Ukrainian artist living and working in the United States, successfully and boldly re-imagined the images of American comic book superheroes in the context of the traditions of Eastern Christian iconography. A professional artist who was educated at the Academy of Arts in Kiev, Valentin Popov has been using comic book characters since 1993, placing them in gold, silver and brass settings typical of those seen in domestic and ecclesiastical Byzantine devotional icons. This is how his trademark amalgams Saint Batman and others came about. The artist has termed the products of this exercise in melding two highly disparate traditions Ironic Icons, thus carrying the viewer to unexpected conclusions, and inviting him to consider two presumably incompatible cultural strands in a new, ironic context.

Using the iconography of Eastern Orthodoxy as a basis for his works – static images of saints and their life scenes, the artist replaces traditional biblical images with superheroes found in popular culture. Yes, characters from popular movies, TV shows, books, and comics, endowed with extraordinary powers, fantastic weapons, and unusual space travel, are accorded yet more endowments and implications by becoming objects of worship.

The irony of Valentin Popov's works resides in the fact that biblical heroes once were fighters for justice and could do wonders, but comic book heroes, however powerful, cannot create miracles. Or can they? Popov leaves the answer to this question open to audience interpretation. The artist does not refer to specific biblical characters in his work and he does not diminish the aura of holiness. He preserves, in his icons, all the trappings of holiness in order to frame and give context to the modern superhero.

The purpose of Valentin Popov's creative experiments is to toy with associations and visualization, which play out in different ways according to their space-time coordinates. The artist uses appropriation, adaptation and transformation – typical methods of postmodernism. The humble spiritual elements of Eastern Christianity are combined in this work with the glamorous world of American pop culture more suited to a celebration of fashion and mass culture than to the customary purposes of objects of adoration. Detached from their usual contexts, whether of sacredness or popular entertainment, familiar images acquire fresh semantics.

Contemporary art seeks to globalize discourse. Valentin Popov's works generate a wave of conflicting associations and contradictory feelings reflecting the values of different cultures affected by the impact of mass culture on the modern world. An artificial and ironic parody of religious dogma acquires its own artistic value, because society needs modern mythology and cultural heroes. As a result, aesthetic and ideological visions are deconstructed, and the "eternal" values are rethought for the sake of constructing a comprehensible future.

Victor Sydorenko

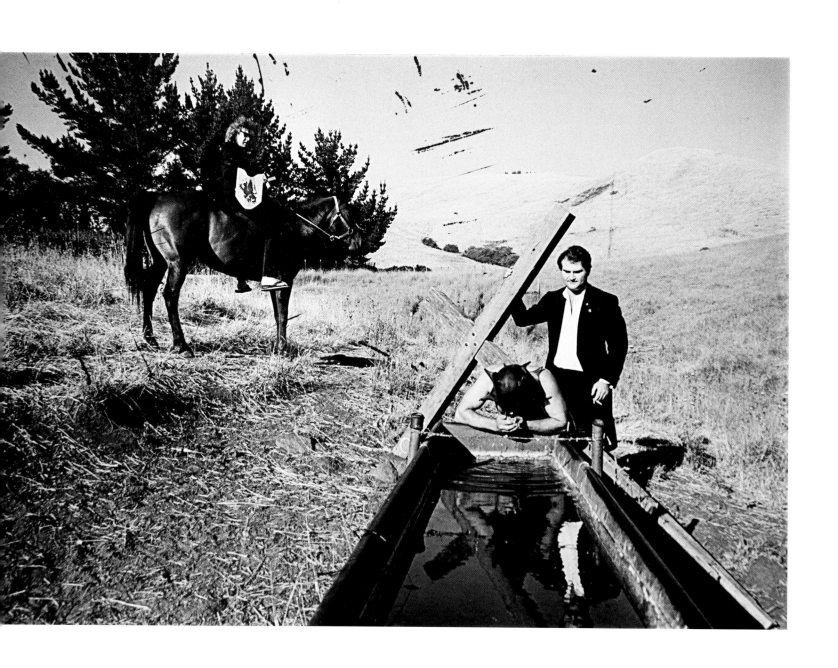

"St Batman Crucifiction" Valentin Popov and David Perry collaboration, split toned with Kodak sepia toner 8.75"x 12.5" edition 20 1994

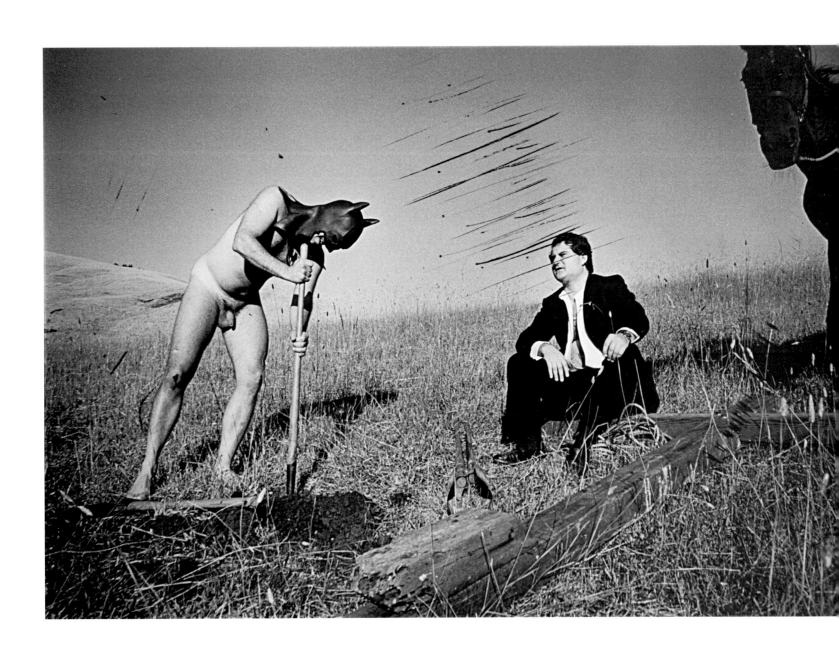

"St Batman Crucifiction" Valentin Popov and David Perry collaboration, split toned with Kodak sepia toner 8.75" x 12.5" edition 20 1994

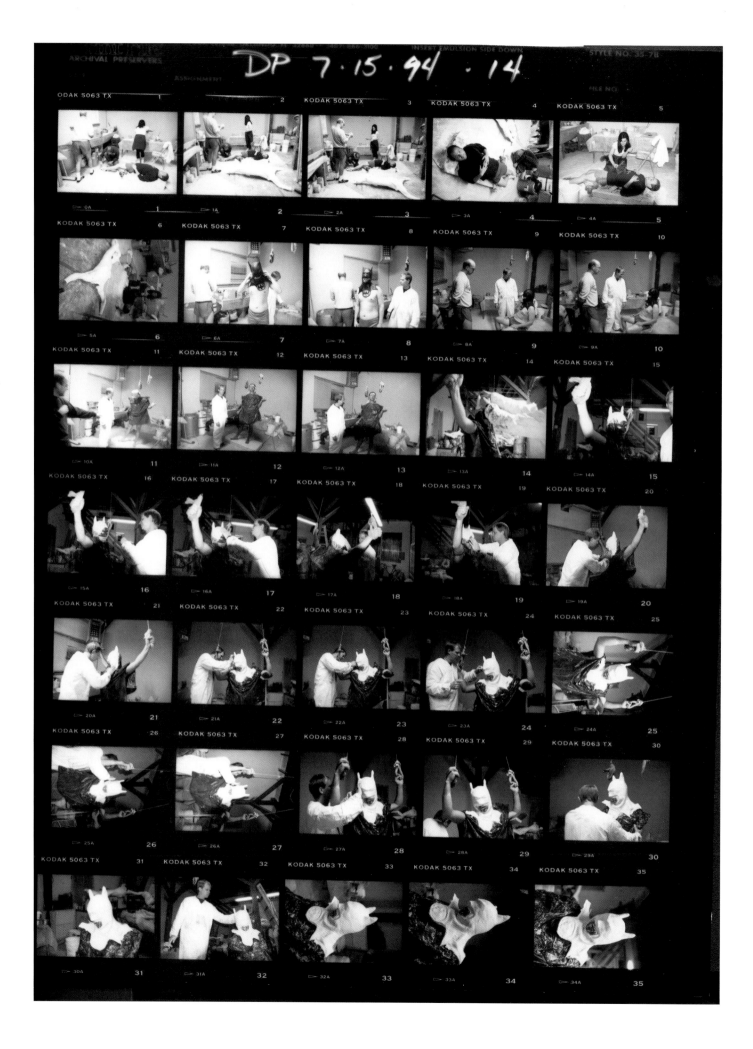

When my friend, Valentin Popov, asked me if I would be willing to crucify Batman, I immediately said "yes."

I had seen Batman recurring in Valentin's art for some time by then and I was ready to help him put a symbolic end to it. I felt my conscience would be clear because, well, if it was really Batman, he was sure to be resurrected. So, on July 12, 1994, Alex Gatti, Valentin Popov, David Perry and myself met at my ranch for the sole purpose of crucifying Batman, (a.k.a. Valentin Popov).

The essence of our understanding that day is captured for me in the exchange I had with a ranch hand. I was riding horseback and and Alex Gatti, the other crucifier, on foot. We were in the midst of shooting Batman in agony, naked but for his mask, dragging a heavy cross up a dirt road, when a car approached from the other direction. David Perry stopped photographing and waved for the car to pass, but the two Spanish-speaking ranch hands sat in the car transfixed, unwilling or unable to proceed.

I rode my horse, Amigo, over to the passenger side of the car and leaned down to speak, but both men continued staring straight ahead. Following the course of their eyes, I turned and saw the entire odd scene from their unique vantage.

"Es Arte." I said.

The passenger looked up at me and then back to the scene before him. With great skepticism he asked, "Es Arte?"

Faced with the interrogative form of my previous simple "Es arte," I looked once again at Valentin standing in the road naked wearing only his Batman mask and shouldering the heavy cross and pondered for a moment, wondering what else to say. I turned back to my interlocutor and calmly nodded my head and said, "Es arte." With that the two ranch hands drove off and we were left to complete the crucifixion.

Some months passed and Valentin was preparing for a major show of his work at the museum of a Catholic university. Valentin's "Batman Period" was well represented in the show and, to complete it, he wanted to include the photographs of the crucifixion and a life-sized plaster cast of a crucified Batman on the cross made for the photos. At the last minute, the curator of the museum refused to include any of the crucifixion images in the show, claiming it did not fit her vision.

Valentin protested and charged the museum with censorship. A local newspaper covered the controversy in its Art section. When I received a copy of the article, there it was: a full page devoted to the subject. Below the word ART was the photograph of Valentin "Batman" Popov dragging his cross up my dirt road, the same view the two ranch hands had beheld.

"Es arte," indeed.

Dale Djerassi
Woodside, California
25 September, 1997

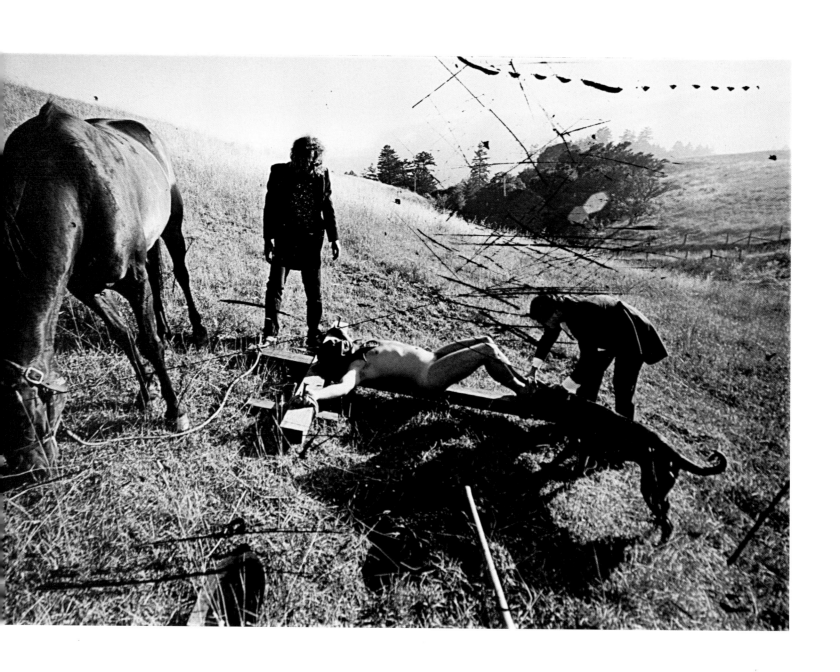

"St Batman Crucifiction" Valentin Popov and David Perry collaboration, split toned with Kodak sepia toner 8.75"x 12.5" edition 20 1994

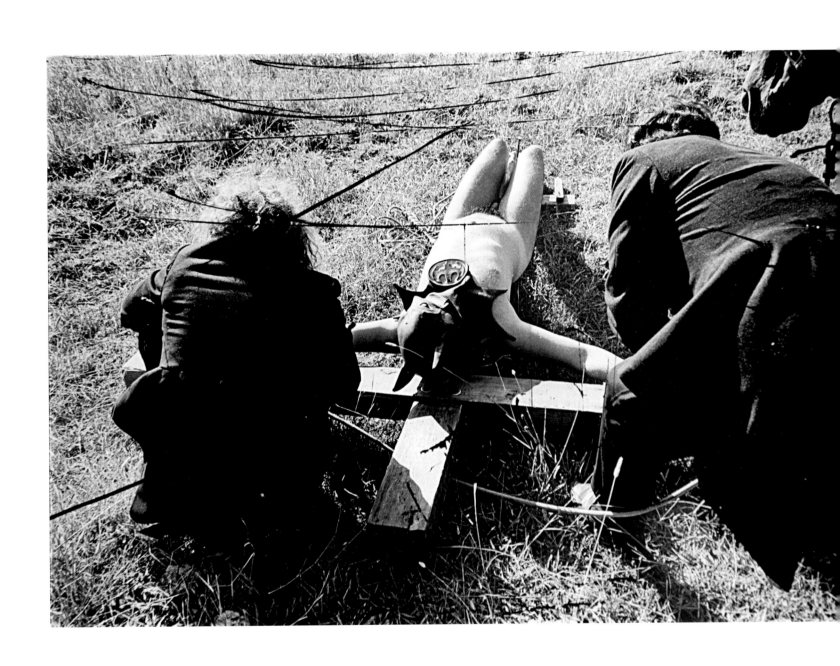

"St Batman Crucifiction" Valentin Popov and David Perry collaboration, split toned with Kodak sepia toner 8.75"x 12.5" edition 20 1994

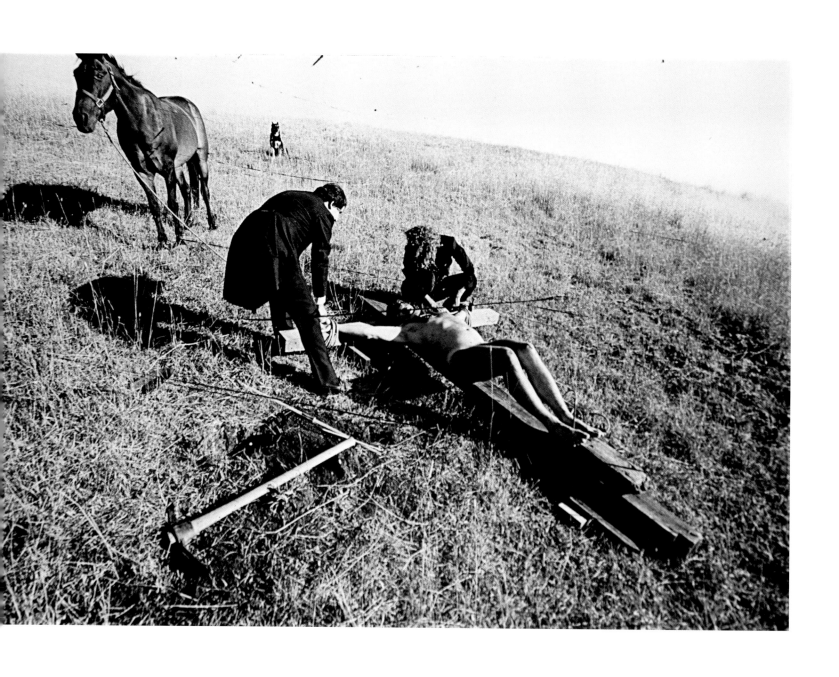

"St Batman Crucifiction" Valentin Popov and David Perry collaboration, split toned with Kodak sepia toner 8.75"x 12.5" edition 20 1994

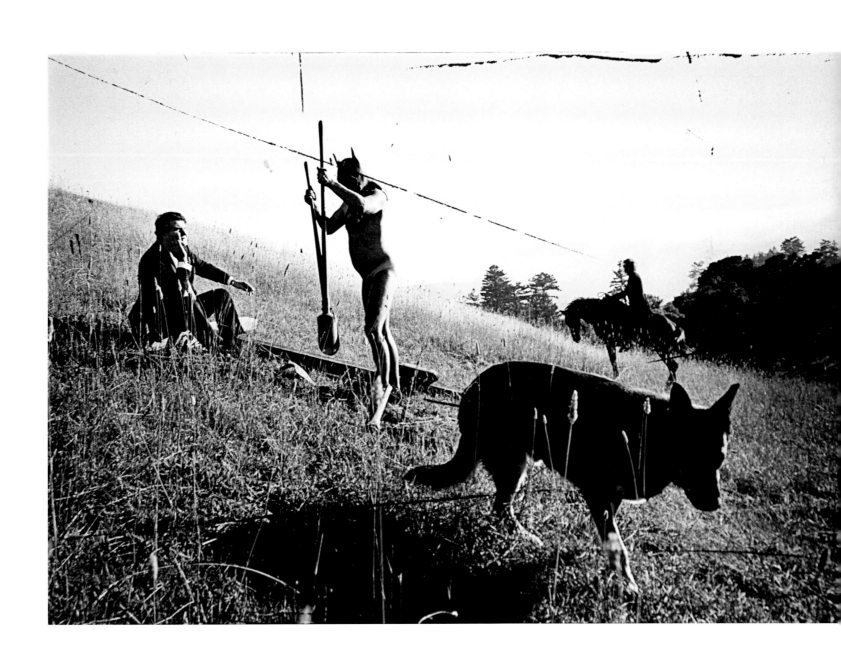

"St Batman Crucifiction" Valentin Popov and David Perry collaboration, split toned with Kodak sepia toner 8.75"x 12.5" edition 20 1994

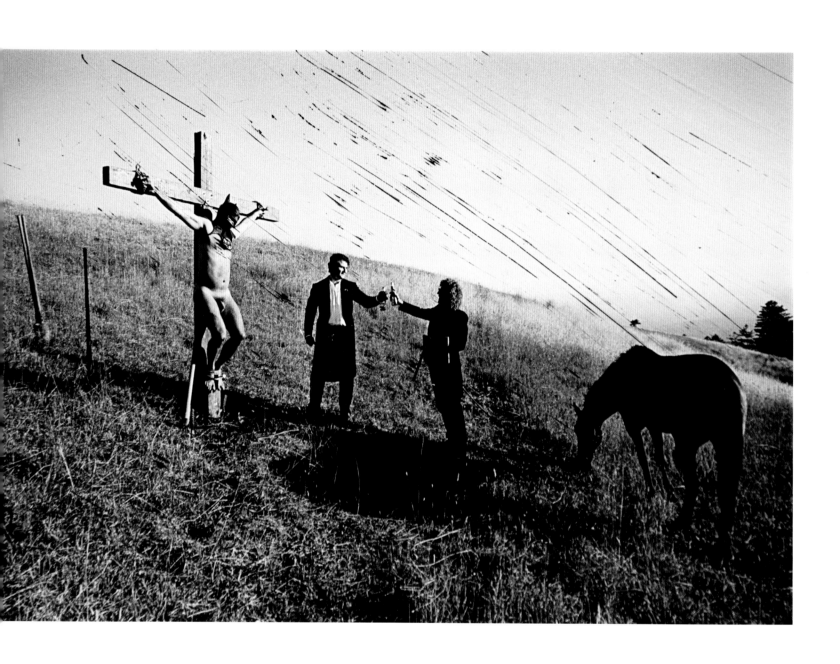

"St Batman Crucifiction" Valentin Popov and David Perry collaboration, split toned with Kodak sepia toner 8.75"x 12.5" edition 20 1994

Wyoming – late evening, Winter 1992.

I am finishing a huge drawing based on an 18th century romantic engraving of clouds, mountains, a nest with a turkey protecting its young from an eagle attacking from the sky. Peacefully contemplating my artwork, I'm suddenly struck with a spontaneous idea: "Let's airbrush the Bat-Signal into the sky. Batman will protect the baby turkey."

Fifteen minutes later, it's done. The piece is completed in a very unexpected way. This is how the creative process works sometimes. I name it "Heroism at the End of the Twentieth Century".

A few weeks later, I'm back in the Bay Area after participating in an art program. I create a little painting like an old Russian icon; but instead of the Christ child, I paint a blue baby with Batman's mask on his head. This work is designed to accompany my large turkey and eagle drawing. Both are met with tremendous success.

I paint a few more icons, make some Batman matroshkas, create some triptychs, black lacquer boxes, and paintings on aluminum. Hundreds of pieces are completed in the course of three years; and as a logical culmination of this series we stage a live performance of the Crucifixion of St. Batman, memorialized in a series of art photographs.

The performance art comes together among friends cum actors. In the piece are Dale Djerassi and Alex Gatti as executioners. (Roman helmets and tunics are exchanged for tails and tuxedo.) The place chosen for our Golgotha is Djerassi Ranch in northern California's Santa Cruz Mountains. I am "forced" to portray Batman in this collaboration. Four hundred photographs are produced from this live – action performance. Seventeen images have been selected for your enjoyment in this publication.

These few lines provide a brief history of the Ironic Icons project – the rest you can explore for yourself in the artwork. But if I remove myself from the history, and think only of the idea (looking past the satire, joking and fun), the deeper meaning leaves a sickening aftertaste of broken dreams, the agony of lost beliefs or faith, and sweet irony. This is what makes this series so memorable and touching.

Think about it.

Valentin Popov
8-19-97
American Airlines SF - NY

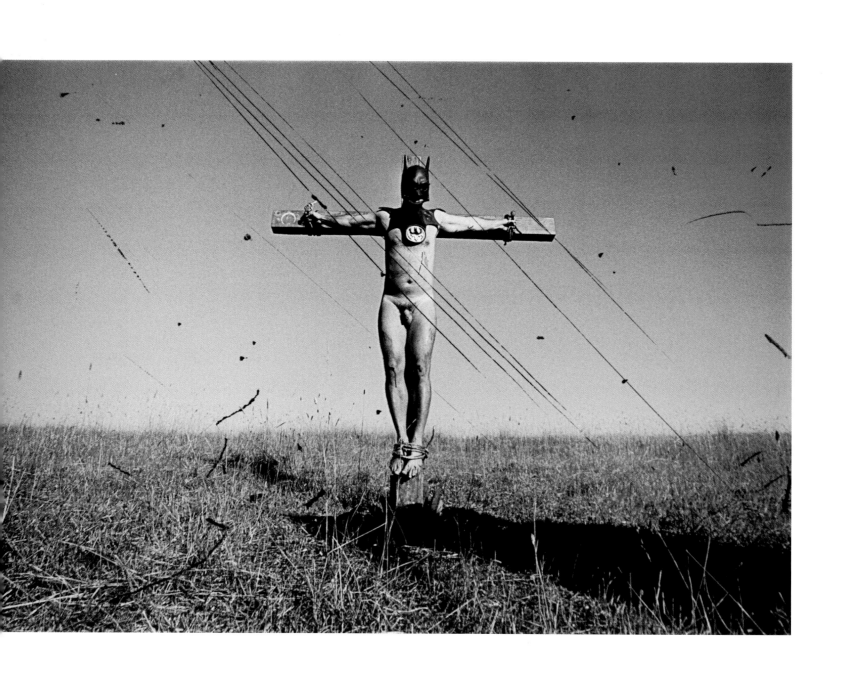

"St Batman Crucifiction" Valentin Popov and David Perry collaboration, split toned with Kodak sepia toner 8.75"x 12.5" edition 20 1994

All of Valentin Popov's friends and I had been exposed to the development of the St. Batman project for a long time. So, when Valentin called me one day asking for my participation in some activity for the final stage of the St. Batman project, I gladly accepted.Little did I know what I was in for. I started getting a sense of an unusual event in the making when the instructions included "meet me at Dale's [Djerassi] ranch and bring your tail suit": I should have known better than to trust Valentin's wildly creative mind! On the B-day, I was fully instructed of Valentin's intent. Dale Djerassi and I had to gear up appropriately: Dale was to mount Amigo, his horse, and I was to walk holding a plastic toy sword. Things had finally gotten to an unbearable point of no return, so that I asked for a final toast before starting the crucifixion, and shouted "Let's kill the sucker once and for all!"

I was very surprised when a few months later the photographs were first shown. The very last one had an empty cross against the sunset. What was its meaning? What had happened to Batman? Did he resurrect from the crucifixion?

More time went by and Valentin's project was being setup for a show at the museum of a Catholic school. However, the photographs and cross had been censored because of the fear that they could have been perceived as disturbingly sacrilegious by some of the museum's visitors. Notwithstanding the fact I grew up and spent half of my life in Italy and studied for eight years in a Jesuit school, I was amazed by such reaction.
Art is Art or "Es Arte", as Dale had very appropriately expressed it! For the past two thousand years artists had been interpreting religion according to their imagination, creating "sacrilegious" work.
Why was it different now? Why should art stop its interpretation of religion?

In hindsight, Valentin's brilliant art had successfully fulfilled its purpose: to create a reaction in people.

Alessandro Gatti
San Francisco, California
November 26, 1997

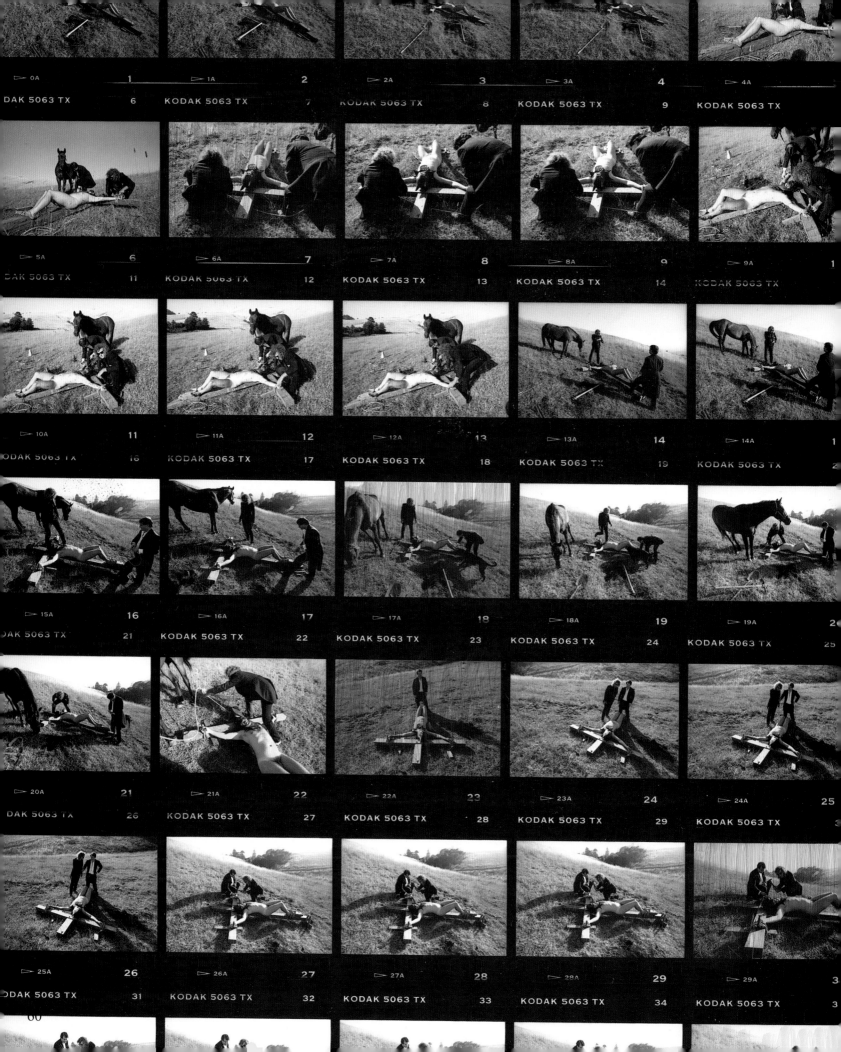

Mockery Squared:
The Paradoxical Parody of Valentin Popov's Ironic Icons

Throughout human history, religious iconography has formed the backbone of "high" art, not only in the western world, but universally. In a sensational and much-heralded tour-de-force of multimedia exoticism, postmodernist artist Valentin Popov has crafted a suite of modified Russian religious artifacts based on the traditional tabletop and wall-mounted folk art icons commonly fashioned from such materials as wood, enamel, hammered metal and gold leaf, and populating the interiors of the humblest of hovels to the most splendid temples of worship. Popov clearly benefits from a lifetime of familiarity with these devotional aids derived from his upbringing as a native Ukrainian surrounded by tokens and trappings of the Eastern Orthodox Church.

Contemporary cultural commentators have observed that, in the present era, the museum has replaced the church and "art is the new religion." In the example of the artwork before us, the psychological framework of religiosity itself is examined through the "ironic" invocation of comic book superheroes as replacements for the old gods. These dubious dramatis personae have been deified and enshrined as the shallow symbols of humanity's desires, fears, hopes and anxieties in the modern age.

The ascendancy of American and British Pop Art during the 1960s was borne on the ideological shoulders of a worship for comic book superheroes, movie stars and commercial trademark characters - mascots of a new mythology based on mass consumer culture. Pop Art brazenly and gleefully parodied these modern icons with a mock reverence, enshrining and sanctifying them. Artist Valentin Popov carries this attitude a step further by transposing camp figures from popular comic books, television and movies for traditional religious figures and then, so as to square the equation with a Dadaist flourish, mocks not only the original intent of the religious icons, but mocks their substitutes, the pop culture preoccupations they represent, and modern art as well, all at the same time. In effect, Popov achieves a double irony, mocking both the original religious intentions of the icons and the celebration of the superficiality of modern consumerist society embodied by Pop Art.

The glib, deadpan nature of Popov's presentation amplifies the effect and solidifies the triumph of the artist's method: the circle has been squared. The deft construction of Popov's creations, involving genuine vintage icons carefully carved, delicately painted and resplendently gilded, is carried off with an attention to detail that heightens the authenticity and cements the impact of each piece. Popov's Rembrandt / Not Rembrandt series of some years back is marked by the same strain of disarming precision and verisimilitude with which Rembrandt etchings were aped in a manner jaw-dropping and spectacular.

Valentin Popov's Ironic Icons represent postmodernism at its best and attest to its validity and durability, demonstrating how a reassessment of art history and its stages, episodes and departments can offer endless possibilities for exploration.

Rick Gilbert

Kurt Schuizman and Richard Nerï Gallery

HRONIC
ICONS

HE ART OF VALENTIN POPOV
JANUARY 12, 2017 - MARCH 19, 2017

FIRE

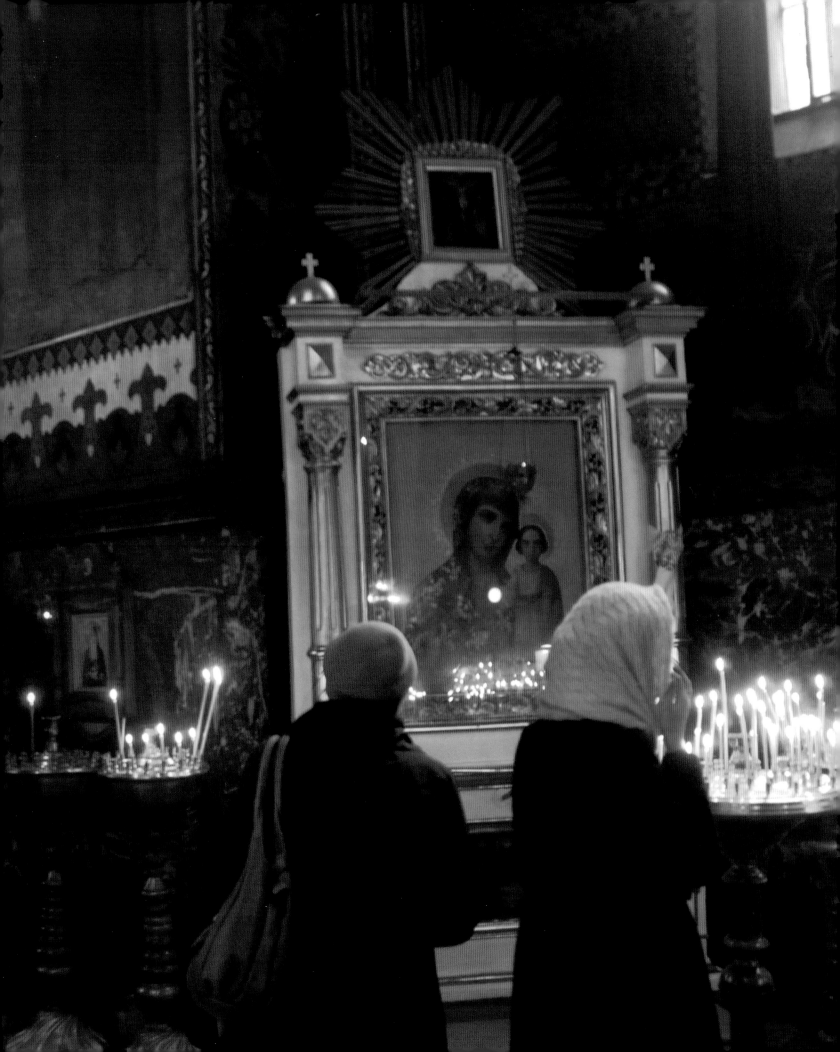

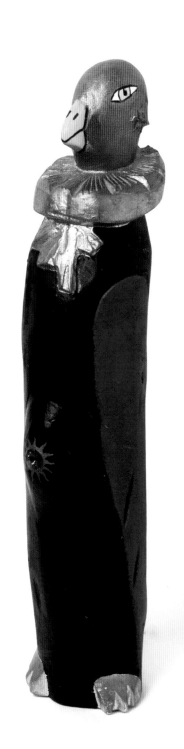

"Pingvin" wood, gesso, oil and gold leaf. 14.25"x3.25" 1992

SLEIGHT OF HAND, SLY OF EYE:
The Postmodernist Prerogative

The provocative and engaging title of multimedia artist Valentin Popov's Ironic Icons project derives from a double root - icons, with their vast and venerable religious history, and the concept of irony, which is an intellectual construct with more heads than a Hydra. The novelty and significance of the present exercise derives from the postmodernist maneuver of manipulating a traditional artifact - a sacred artifact, at that - in a new and different manner. Popov wryly imitates the traditional icon format involving a central panel featuring a holy personage surrounded by a border of thumbnail panels depicting episodes in the holy personage's life. Popov takes as his raw material genuine Russian icons pre-dating the requisition of the church in the aftermath of the Revolution which were noted for their magnificence and resplendence, and were often associated with miracles.
The irony in Popov's assemblage series consists largely in the shock effect that results from the juxtaposition of incongruous visual cues and the cross-fertilization of high culture with popular or mass culture elements.

Irony, according to Merriam-Webster, refers to the incongruity between the actual result of a sequence of events and the normal or expected result. Irony challenges our preconceptions and expectations, to provide a voice to an otherwise "invisible" space. Verbal irony consists of the expression of one's meaning by using language that normally signifies the opposite, typically for humorous or emphatic effect. Visual, dramatic or situational irony results from a scene, a state of affairs or an event that seems deliberately contrary to what one expects or comprises a drastic and obvious understatement of a factual connection. Irony, in its broadest sense, is a rhetorical device, literary technique, or event in which what appears, on the surface, to be the case, differs radically from what is actually the case.

In *Ironic Icons*, the irony lies in the substitution of contemporary pop culture superheroes such as Batman for the traditional ecclesiastic ensemble of saintly figureheads to create something novel in which the whole is greater than the sum of its parts. This transference or substitution of components has historical antecedents in early Modernism with works such as Bull's Head, a found object artwork by Pablo Picasso, created in 1942 by assembling the reconfigured seat and handlebars of a discarded bicycle. The sculpture is a classic example of a set of visual elements removed from their usual context and modified so as to force reinterpretation and fresh perspective. Such prestidigitation of components aids the phenomenon of disorientation in the beholder, who is struck by the jolt of imagery giving the sense of being "out of place." Members of the Surrealist group in Paris, most active during the 1920s and 1930s, created many paintings which still today surprise and startle the viewer by juxtaposing incongruous pictorial elements.

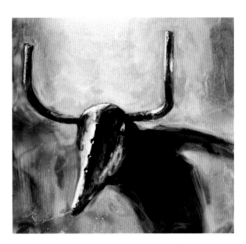

Picasso Bull's Head by Valentin Popov 2020

An earlier example of this phenomenon is Fountain, a readymade sculpture produced by Marcel Duchamp in 1917: a porcelain urinal inverted, renamed, and submitted for an exhibition of the Society of Independent Artists at The Grand Central Palace in New York. The creation of Fountain began when the artist purchased a standard Bedfordshire model urinal from the J. L. Mott Iron Works, brought the urinal to his studio at 33 West 67th Street, reoriented it to a position 90 degrees from its normal position of use, and wrote on it, "R. Mutt 1917".

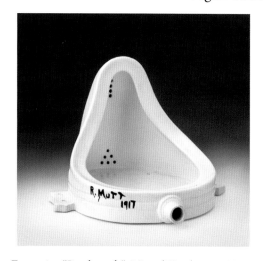

The work is regarded by art historians and theorists of the avant-garde as a major landmark in 20th century art. Whether Duchamp with his own hands made the fountain or not has no importance. He chose it. He took an ordinary article of life, placed it so that its useful significance disappeared under the new title and point of view, and created a new thought for that object. Duchamp described his intent with the piece was to shift the focus of art from physical craft to intellectual interpretation. The legacy of

Fountain, "Readymade", Marcel Duchamp, 1917

Duchamp's Fountain was to be voted the most influential artwork of the 20th century by 500 selected British art world professionals. Duchamp adamantly asserted that he wanted to 'de-deify' the artist, notes Jerry Saltz. "The ready-mades provided a way around inflexible either-or aesthetic propositions. They represented a Copernican shift in art. Fountain is what's called an 'acheropoietoi,' an image not shaped by the hands of an artist."

Duchamp himself wrote, "When I discovered the ready-mades I sought to discourage aesthetics. In Neo-Dada they have taken my ready-mades and found aesthetic beauty in them. I threw the bottle rack and the urinal into their faces as a challenge and now they admire them for their aesthetic beauty! Pop Art is a return to 'conceptual' painting, virtually abandoned, except by the Surrealists, since Courbet, in favor of retinal painting If you take a Campbell soup can and repeat it 50 times, you are not interested in the retinal image. What interests you is the concept that wants to put 50 Campbell soup cans on a canvas."

Andy Warhol's soup cans have become icons of the modern age, but icons used primarily in religious settings have been around for millennia. An icon is a religious work of art, most commonly a painting, from the Eastern Orthodox Church, Oriental Orthodoxy, and certain Eastern Catholic churches. The most common subjects include Christ, Mary, saints or angels. Though especially associated with "portrait" style images concentrating on one or two main figures, the term also covers most religious images in a variety of artistic media including narrative scenes.

Icons may be cast in metal, carved in stone, embroidered on cloth, painted on wood, done in mosaic or fresco work, printed on paper or metal. Valentin Popov has contrived composites involving actual vintage icons mounted on wood blocks or in acrylic boxes, modified and, to some extent modernized, with doctored images, cryptic symbols, jewels, gold leaf and a miscellany of other decorative touches.

Eastern Orthodox tradition holds that the creation of Christian images dates back to the very early days of Christianity, and there has been a continuous tradition since then. From as early as the 4th century, many Christian church officials opposed icons on the grounds that they encouraged idolatry. In the year 305 A. D. Spanish bishops proclaimed that, "Pictures are not to be placed in churches, so that they do not become objects of worship and adoration." When Emperor Constantine's sister asked churchman and historian Eusebius for an image of Jesus, he refused, saying, "To depict purely the human form of Christ before its transformation is to break the commandment of God and to fall into pagan error."
There was a continuing opposition to images and their misuse within Christianity from very early times. Nonetheless, popular favor for icons guaranteed their continued existence, while no systematic apologia for or against icons, or doctrinal authorization or condemnation of icons yet existed.

The use of icons was seriously challenged by Byzantine Imperial authority in the 8th century. The Iconoclastic Period began when images were banned by Emperor Leo III the Isaurian sometime between 726 and 730. Under his son, Constantine V, a council forbidding image veneration was held at Hieria near Constantinople in 754. Image veneration was later reinstated by the Empress Regent Irene, under whom another council was held reversing the decisions of the previous iconoclast council. The council anathemized all who held to iconoclasm, i.e., those who held that veneration of images constitutes idolatry.

The tradition of acheiropoieta (literally "not-made-by-hand") accrued to icons that are alleged to have come into existence miraculously, not by a human painter. Such images functioned as powerful relics as well as icons, and their images were naturally seen as especially authoritative as to the true appearance of the subject: naturally and especially because of the reluctance to accept mere human productions as embodying anything of the divine, a commonplace of Christian deprecation of man-made "idols". Like icons believed to be painted directly from the live subject, they therefore acted as important references for other images in the tradition.

Hans Belting writes, "As we reach the second half of the sixth century, we find that images are attracting direct veneration and some of them are credited with the performance of miracles." However, the earlier references by Eusebius and Irenaeus indicate veneration of images and reported miracles associated with them as early as the 2nd century. In the Eastern Orthodox Christian tradition there are reports of particular wonderworking icons that perform miracles upon petition by believers. Theologically, all icons are considered to be sacred, and are miraculous by nature, being a means of spiritual communion between the heavenly and earthly realms. This is because icon painting is rooted in the theology of the Incarnation (Christ being the icon of God).

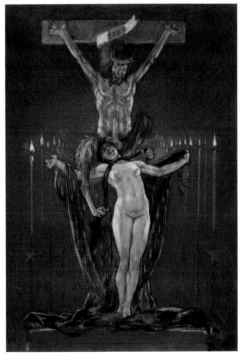

Calvary, Felicien Rops, 1882

In the icons of Eastern Orthodoxy very little room is made for artistic license. Almost everything within the image has a symbolic aspect. Christ, the saints, and the angels all have halos. Angels have wings because they are messengers. Figures have consistent facial appearances, hold attributes personal to them, and use a few conventional poses. Color plays an important role as well. Gold represents the radiance of Heaven; red, divine life. Blue is the color of human life, white is the Uncreated Light of God, only used for resurrection and transfiguration of Christ. Letters are symbols, too. Most icons incorporate some calligraphic text naming the person or event depicted. Even this is often presented in a stylized manner.

It was only in the Comnenian period (1081–1185) that the cult of the icon became widespread in the Byzantine world, partly on account of the dearth of richer materials (such as mosaics, ivory, and vitreous enamels),

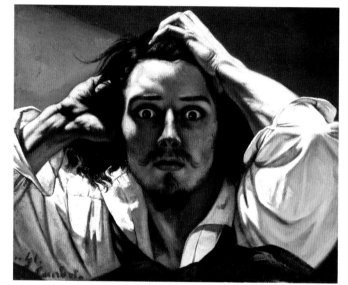

The Desperate Man, Gustave Courbet

iconostasis, a special
introduced then in
The style of the time
and distant.

In Popov's usage,
stand-ins and
book characters for
figures. Chief
superhero Batman,
Saint Batman,
amalgam concocted
his own mythology
Batman, of course,
superhero typifying
which originated
star Superman

but also because an
screen for icons, was
ecclesiastical practice.
was severe, hieratic

the icon features
surrogates of comic
prominent religious
among these is the
here translated to
an idiosyncratic
by Popov replete with
and fictive universe.
is a comic book
the superhero model
with the comic book
in 1938 and has

since spawned dozens of imitators. The concept of the superman began with the 19th century German philosopher Friedrich Nietzche, who elucidated the concept of the "übermensch" in one of his allegorical treatises. The übermensch, German for "beyond-man", "overman", "hyperhuman", or "superman", is posited as a goal for humanity to set for itself. The superman is regarded as the next step in human evolution, who overcomes the herd perspective and is capable of creating a new perspective without dogmatically forcing his perspective on others. The comic-book hero Superman was originally a villain modeled on Nietzsche's idea, later re-invented as a hero.

A superhero is a type of heroic stock character, usually possessing supernatural or superhuman powers, who is dedicated to fighting the evil of the universe, protecting the public, and usually battling supervillains. Superman in 1938 and Captain Marvel in 1939 heralded the beginning of the Golden Age of Comic Books and superheroes. Superman remains one of the most recognizable superheroes to this day. The success of Superman spawned a whole new genre of characters with secret identities and superhuman powers. Superheroes and superheroines such as Superman, Spider-Man, Batman, Wonder

Woman, Hulk, Green Lantern, the Flash, Captain America, Thor, Wolverine, Iron Man and the X-Men have done combat with a rogues gallery of many villains.

Popov has adopted some of these figures as emblems, fusing the "lowbrow" artifacts of superheroes and superheroines such as Superman and Wonder Woman with the orthodox retinue of traditional Christian avatars and archetypes - Jesus, angels, saints, and martyrs.

Social commentator Dwight MacDonald observes that, "For about a century, Western culture has really been two cultures: the traditional kind - let us call it 'High Culture' – that is chronicled in the textbooks, and a 'Mass Culture' impersonally manufacturing impersonal wholesale commodities for the marketplace. In the old art forms, artisans of Mass Culture have long been at work: in the novel, the line stretches from Eugene Sue to Lloyd C. Douglas; in music, from Offenbach to Tin Pan Alley; in art from the chromo to Maxfield Parrish and Norman Rockwell; in architecture, from Victorian Gothic to suburban Tudor. Mass Culture has also developed new media of its own, into which the serious artist rarely ventures: radio, the movies, comic books, detective stories, science fiction, television.

It is sometimes called 'Popular Culture,' but I think 'Mass Culture' a more accurate term, since its distinctive mark is that it is solely and directly an article for mass consumption, like chewing gum. The historical reasons for the growth of Mass Culture since the early 1800s are well known. Political democracy and popular education broke down the old upper class monopoly of culture. Business enterprise found a profitable market in the cultural demands of the newly awakened masses, and the advance of technology made possible the cheap production of books, periodicals, pictures, music, and furniture, in sufficient quantities to satisfy this market. Modern technology also created new media such as movies and television, which are especially well adapted to mass manufacture and distribution. The phenomenon is thus peculiar to modern times and differs radically from what was hitherto known as art or culture. It is true that Mass Culture began as, and to some extent still is, a parasitic, a cancerous growth on High Culture. As Clement Greenberg pointed out: 'The precondition of kitsch (a German term for Mass Culture) is the availability close at hand of a fully matured cultural tradition, whose discoveries, acquisitions, and perfected self consciousness kitsch can take advantage of for its own ends.' The connection, however, is not that of the leaf and the branch, but rather that of the caterpillar and the leaf. Kitsch mines High Culture the way improvident frontiersmen mine the soil, extracting its riches and putting nothing back. Also, as kitsch develops, it begins to draw on its own past, and some of it evolves so far away from High Culture as to appear quite disconnected from it.

It is also true that Mass Culture is to some extent a continuation of the old Folk Art, which until the Industrial Revolution, was the culture of the common people, but here, too, the differences are more striking than the similarities. Folk Art grew from below. It was a spontaneous, autochthonous expression of the people, shaped by themselves, pretty much without the benefit of High Culture, to suit their own needs. Mass Culture is imposed from above. It is fabricated by technicians hired by business; its audiences are passive consumers, their participation limited to the choice between buying and not buying. The Lords of kitsch, in short, exploit the cultural needs of the masses in order to make a profit. (It is very different to satisfy popular tastes, as Robert Burns' poetry did, and to exploit them, as Hollywood does.) Folk Art was the people's own institution, their private little garden walled off

from the great formal park of their masters' High Culture. But Mass Culture breaks down the wall, integrating the masses into a debased form of High Culture and thus becoming an instrument of political domination. Whereas Folk Art had its own special quality, Mass Culture is at best a vulgarized reflection of High Culture. And whereas High Culture could formerly ignore the mob and seek to please only the cognoscenti, it must now compete with Mass Culture or be merged into it.

The problem is acute in the United States and not just because a prolific Mass Culture exists here. If there were a clearly defined cultural elite, then the masses could have their kitsch and the elite could have its High Culture, with everybody happy. But the boundary line is blurred. A statistically significant part of the population, I venture to guess, is chronically confronted with a choice between going to the movies or to a concert, between reading Tolstoy or a detective story, between looking at old masters or at a TV show; i.e., the pattern of their cultural lives is open to the point of being porous. Good art competes with kitsch, serious ideas compete with commercialized formulae - and the advantage lies all on one side. There seems to be a Gresham's Law in cultural as well as monetary circulation: bad stuff drives out the good, since it is more easily understood and enjoyed. It is that facility of access which at once sells kitsch on a wide market and also prevents it from achieving quality. Clement Greenberg writes that the special aesthetic quality of kitsch is that it 'predigests art for the spectator and spares him effort, provides him with a shortcut to the pleasures of art that detours what is necessarily difficult in genuine art' because it includes the spectator's actions in the work of art itself instead of forcing him to make his own responses.

When to this ease of consumption is added kitsch's ease of production because of its standardized nature, its prolific growth is easy to understand. It threatens High Culture by its sheer pervasiveness, its brutal, overwhelming quantity. Like nineteenth century capitalism, Mass Culture is a dynamic, revolutionary force, breaking down the old barriers of class, tradition, taste, and dissolving all cultural distinctions. It mixes and scrambles everything together, producing what might be called homogenized culture.

This trend of fusing high and low, of homogenization or mongrelization, has further matured and metamorphosed into a full-blown condition we call the School of Postmodernism, of which Valentin Propov is a prime practitioner."

This principle of conflating high and low culture was set into high gear by Andy Warhol and other pop artists, who mocked high art and pop culture both by elevating ordinary everyday commercial objects to an exalted position. Later, Postmodernism would assimilate, interblend, and sanction these aspects of Pop Art with the languages of kitsch, l'art pompier, lowbrow, neoclassicism, and surrealism to create a climate in which "anything goes" and appropriation, quotation, even plagiarism is rampant and acceptable. There has been a distinct irony in this process and it is one which certain historians consider to have been initiated by Warhol and which has self-perpetuated ever since. These historians regard Warhol as irony's apotheosis.

Andy Warhol (1928 –1987) is one of the most important artists in the twentieth century and remains one of the most influential figures in contemporary art and culture. Irony can be widely observed in Warhol's art. He created irony by breaking rules, incorporating culture, and creating ambiguity.

Andy Warhol started his career as an advertisement illustrator in the 1950s and soon moved into the fine art world. Pop art emerged in the late 1950s in the United States as a reaction to Abstract Expressionism. Pop artists, including Warhol, viewed the work created by abstract expressionists as alienating to the public, as it seemed to only be understood by the high art community. Conversely, Pop Art is based on imagery of popular culture and consumerism, lending itself to a wider audience.

Applying the concept of advertising to his art form, Warhol utilized the images of consumer products, celebrities, news stories and the process of repetition to highlight the concept of mass production, quite the opposite from the convention of high art where pieces are considered one of the kind. He blurred the line between high art and commerce both from the execution and the subject matter perspectives. He replicated American commercial products on canvas, such as Campbell soup cans and Coca-cola bottles. The repeated images, as if they are mass-produced even though he painstakingly painted some of them, completely disregard the well-honored artist's hand but celebrate the artist's mind leading to one of Warhol's mantras: 'It is the idea that matters, not the production of it'. The repeated images represent the effect of advertising on people as the more we see them, the more we become desensitized to them. Warhol's work feels removed yet gripping. The artist often was ambiguous about the existence of meaning behind his work, leaving it to the viewer's interpretation.

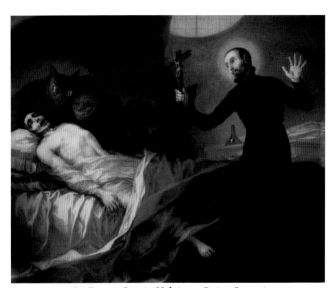

St. Francis Borgia Helping a Dying Impenitent
Francisco Goya, 1788

One of the strategies that Andy Warhol employed to create irony was breaking rules. He broke the rule of well-honored convention of painting and sculpture to which the artist's hand is the essence of the art. Warhol's work separates execution from concept, attesting that it is the artist's mind that matters. Making the touch of the artist irrelevant to the authenticity of the painting is one significant element in the conceptual revolutions that made the art of the twentieth century so different from the art of all earlier centuries. One of the most recognizable works of irony from Andy Warhol is Campbell's Soup Cans. It consists of thirty-two canvases each portraying a unique flavor of Campbell's soup, representing the thirty-two varieties offered by the company at the time. This set of canvases was done before he started using silk-screening. He traced the image from a photograph, using a projector to make a larger image. Then he painted each canvas to create an effect of mechanical production, void of an artist's touch. His intent of removing the human touch from the painting and making them look like prints breaks the rule of traditional painting and sculpture. Moreover, the fact that he had to painstakingly paint the canvas to make them look mass produced, something much less worthy, is ironic itself. On a number of occasions Warhol declared he played no part in the execution of his works.

Andy Warhol's home life was deeply religious. His mother, who was a great influence on him, was

devout. Warhol regularly attended services at the Byzantine Catholic Church in Pittsburgh. This was what one friend described as Warhol's "secret piety". Another colleague cites how, when Warhol traveled abroad, he visited churches and, to the bemusement of observers, displayed incisive knowledge about the artworks adorning their interiors. Warhol's childhood home was filled with religious imagery, most notably, with icons; he is said to have "kept a Byzantine Orthodox prayer book by his bed and other related devotional objects nearby."

Scholar Rina Arya, in her insightful study of Warhol, concludes the chief impetus for Warhol's artistic approach was the notion of the icon as the incarnation of the divine, untouchable and untouched by human contamination. This concept of the icon as the spirit made flesh is most plainly expressed by the iconostasis or wall of icons which appears in Eastern Orthodox churches as a dividing line between the physical world and the supernatural. So literally has this concept of the reification of spirit in the icon been entrenched down through the ages that it created historic upheavals such as the Byzantine iconoclasm controversy of the eighth and ninth centuries. "The iconoclasts' main charge was against the worship of idols, or false gods, in the form of images. The iconophiles' defense against that charge was their successful strategy of incorporating their opponents' iconoclastic critique of the image into the images themselves as a kind of homeopathic ingredient that would ward off the charge of idolatry. It is this distinctive self-protectiveness or defensiveness - the defensiveness of an image that denies us its own status as an image - that we will find at the heart of Warhol's mature artistic enterprise.

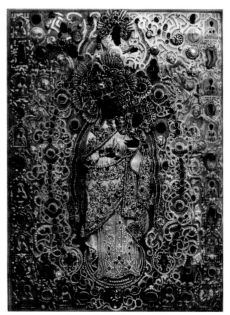

A precious Russian icon
Joy of All Who Sorrow, 1862

"At the center of this solution, developed more than a millennium ago, was the theological issue of whether or not images can represent or constitute the multiple states of being associated with Christ - human and divine, or those of man, God and Holy Spirit - and its resolution in the Byzantine theory of the icon, which lives on today first and foremost in Eastern Rite churches such as the one in which Warhol was raised. As one scholar describes the controversy, the iconoclasts failed to recognize what the iconophiles saw in the image: that an icon does not represent 'His divinity or His humanity, but His Person, which inconceivably unites in itself these two natures without confusion and without division.

"This theory of the image that finally won out based its claim on the older doctrine of a hypostatic union, or unity of multiple states of being in one entity, but what was new was the theological work of the icon as a material realization of that unity. The resolution of the iconoclasm controversy in the ninth century, a resolution that remains today, was an incorporation of this theological principle into the theory of the image and the experience it provides.

"The distinguishing characteristic of the iconophilic Byzantine tradition that grew out of this historic debate is the way the doctrine of multiple states of being lived on was experienced in the material presence of divinity in the icon, rather than in the Word as an immaterial relay from God. The upshot of this Eastern difference is a distinctive relationship with images and a unique model of aesthetic experience - a difference that would come to be the single most significant marker of Warhol's transformation of modern art. Christ's divinity could be represented positively in the Word without fear, but when represented in imagery it was subject to the charge of idolatry. The solution to this problem for the Byzantine Rite liturgical tradition was to privilege apophasis, or a negative theology, in which the image-cum-icon is understood to be more than just a representation. The icon took on a special status distinct from representation by becoming a material incarnation of a theological truth, housing divinity inside or behind its flat surface as a negative or unrepresented interiority or otherness and, thus, as a figure of the doctrine of hypostatic union. Divinity existed as a secret truth or covert life of the icon, as a part of what it was rather than a part of what it represented. As such, the icon is not based on a concept of representation at all, but instead on a manner of substitution or extension, inhabitation or possession.

"It is this idea of inhabitation or possession that we see in Warhol's work, and it will be at the heart of how we characterize his postmodernism. In contrast to our Western notion of mimesis as the imitation of form, Byzantine mimesis is the imitation of presence. What Byzantine seeing required in order to make its claim as immediate evidence of godly presence, was a distancing technique, a way of producing a barrier or membrane between the viewer and the realm of the sacred, creating a sense of blocked access. Several Eastern Rite artistic and architectural conventions carry on today that realize this aim - first and foremost the icon itself, and second the iconostasis or screen separating the sacred area of the altar from the congregation - and these conventions were the basis of Warhol's earliest, and arguably most formative, relationship to art. The iconostasis is a boundary between the visible and invisible worlds. The iconostasis served as material evidence of divinity because it materially separates sacred space from profane space.

"As modern art began to close off access to the Renaissance's illusionistic trickery and draw the beholder out of the clutches of perspectival vision and back to the surface, the realm of distant truth not immediately accessible to the beholder's power of reason was reconstituted, producing a measure of the same Wizard-of-Oz effect, the same apophasis, as icons and the iconostasis, the same unapproachable distance as the work of Andy Warhol.

"Distancing, it can be said without controversy, was the single most effective trick in Warhol's kit and, more than anything else, has come to characterize the larger post-Kantian, post-Enlightenment, postmodern sensibility that he helped to define - more than new media and materials, for example, or more than the turn from craft production to industrial and intellectual production methods; more, even, than renewed efforts at the internationalization and collectivization of artistic labor. Some of that distance was simple irony, mockery and camp."

Like Warhol, who deliberately or inadvertently mocked the art establishment by elevating commercial art techniques and subject matter, Popov goes a step further by mocking the pretensions of Pop Art. Where Warhol took all this irony, Popov picks it up and carries it to a second remove, compiling and compounding it into a double irony by simultaneously satirizing and celebrating the triumph of mass culture and its emblems.

Rick Gilbert

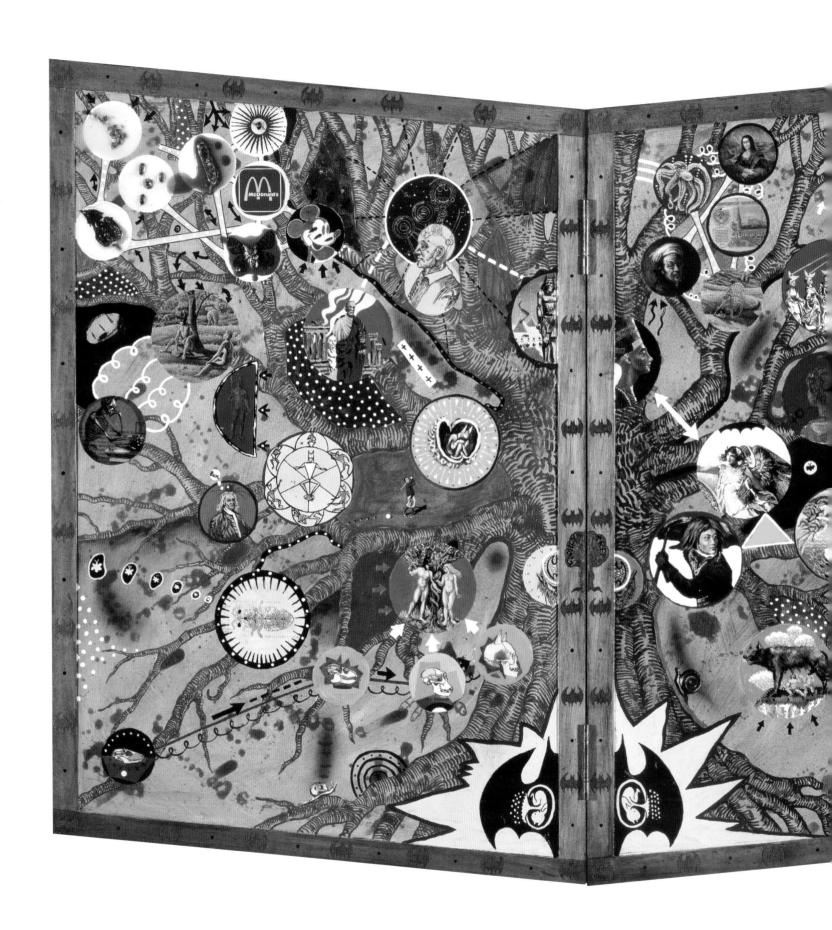

"One Mistake…" oil and collage on wood, diptych, exterior and interior 31"x45" 1993

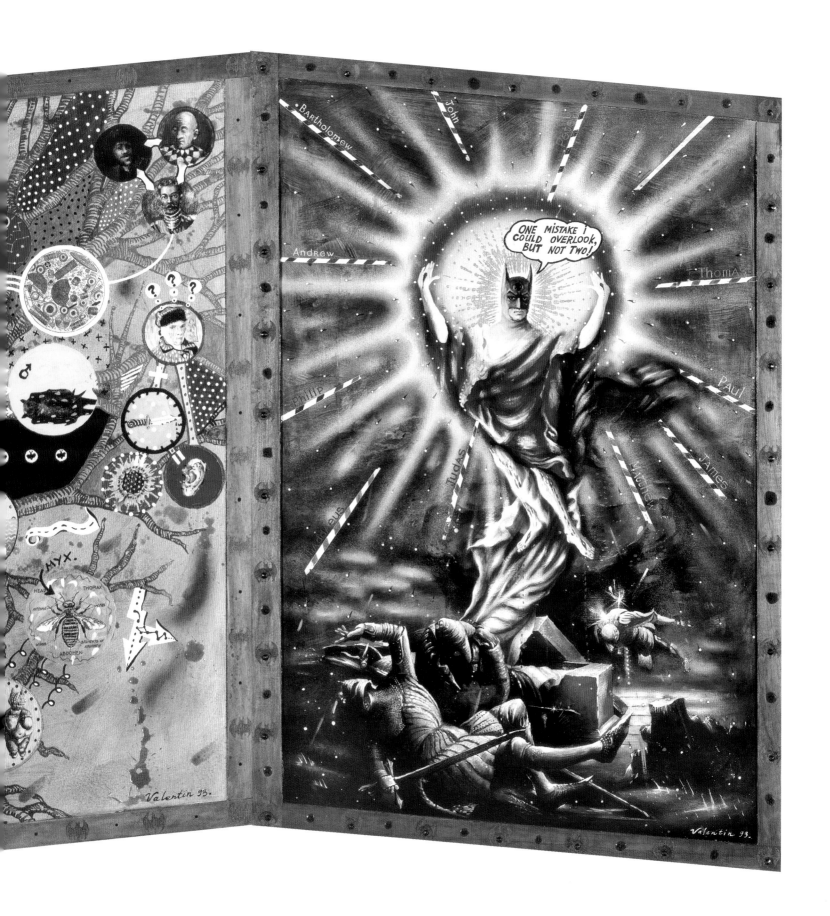

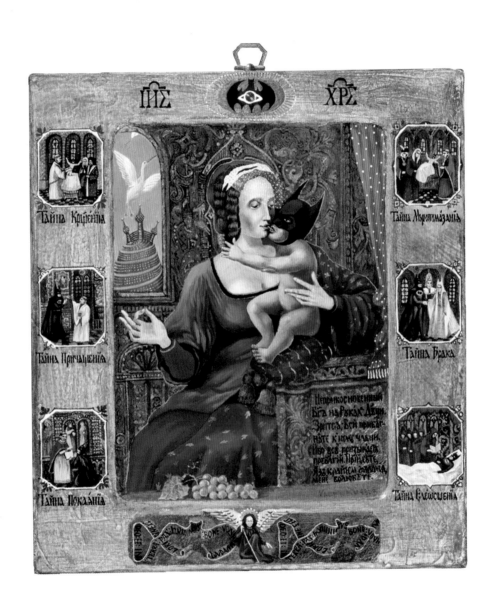

"Batman Icon" oil on gilded wood block 12"x11" 1993

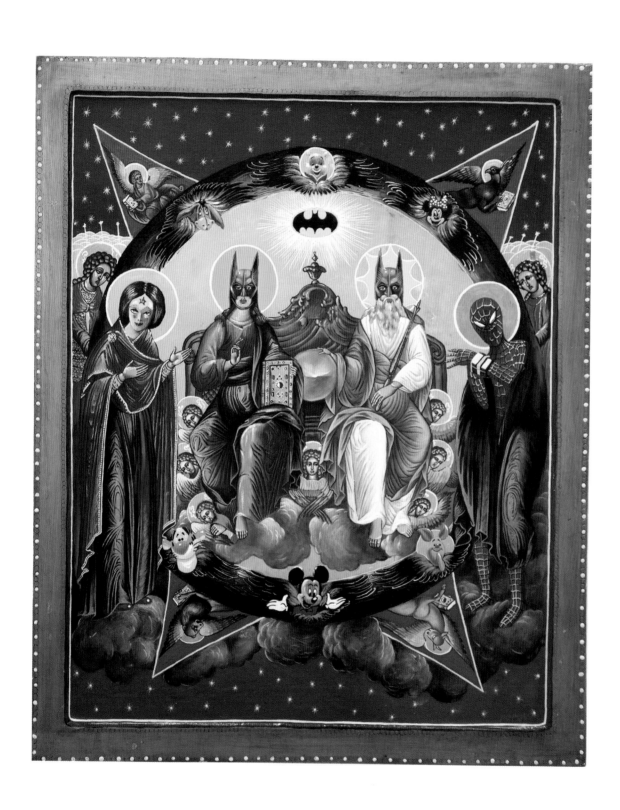

"Trinity" oil on wood block, gold leaf 24"x19.5" 2010

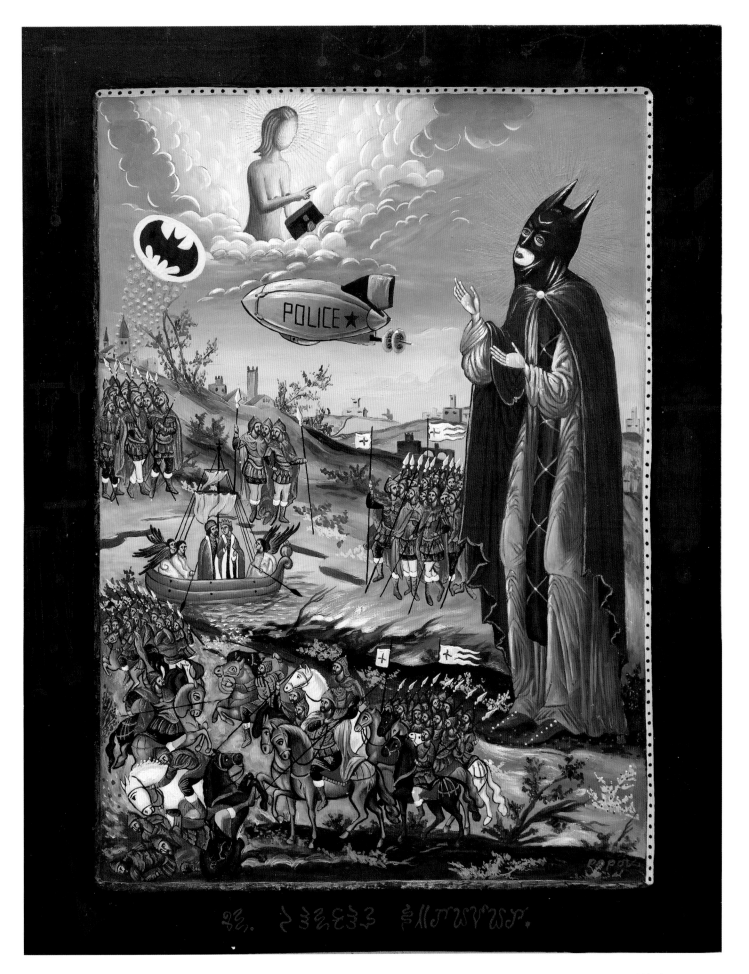

"St.Batman Warrior" oil on wood block, gold leaf 24"x19.5" 2010

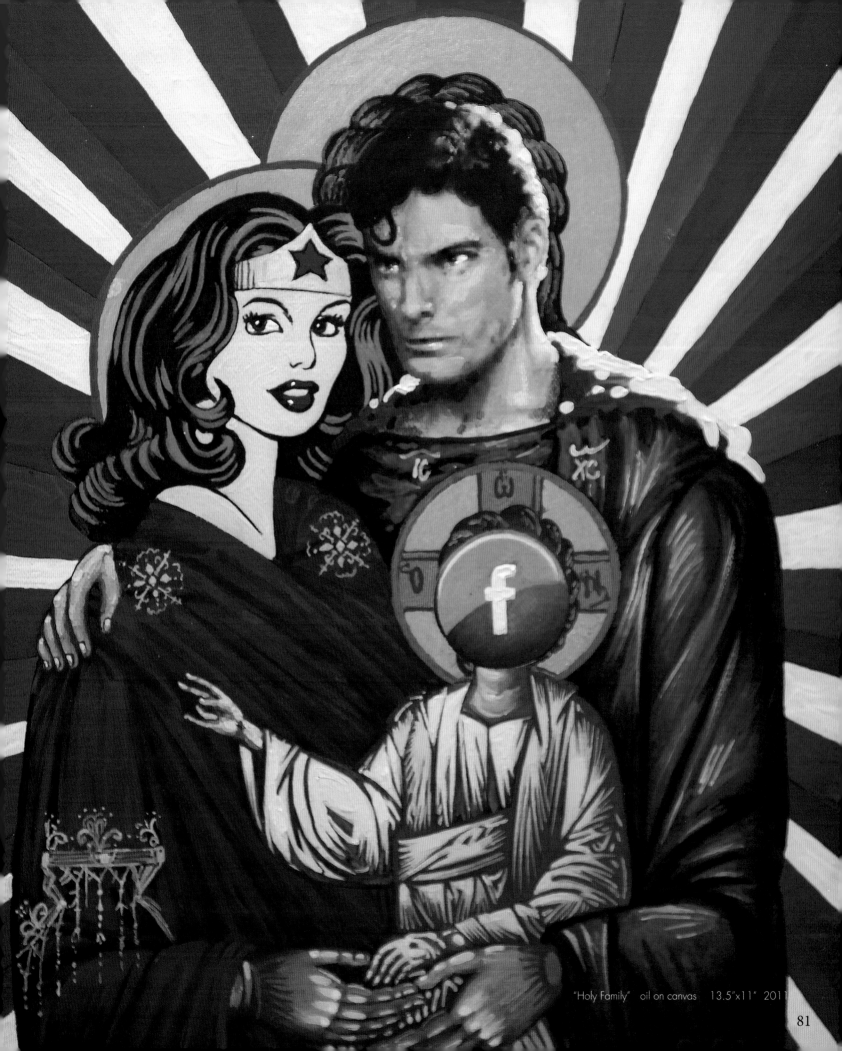

"Holy Family" oil on canvas 13.5"x11" 2011

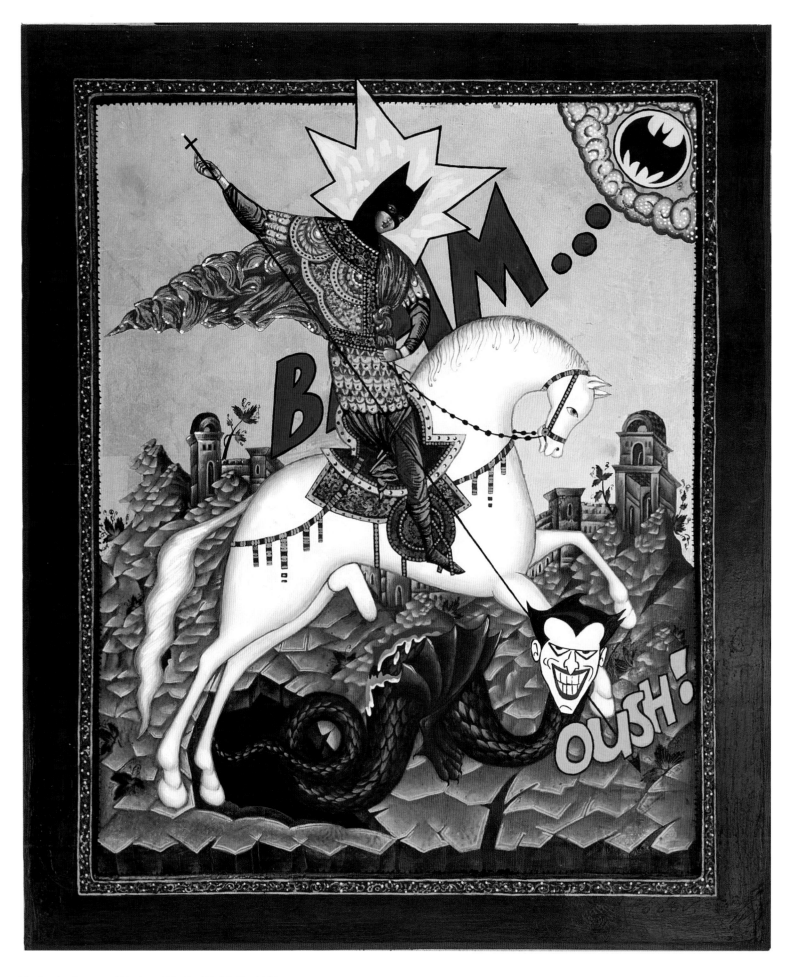

"Ouch…" oil on wood block, gold leaf 24"x19.5" 2010

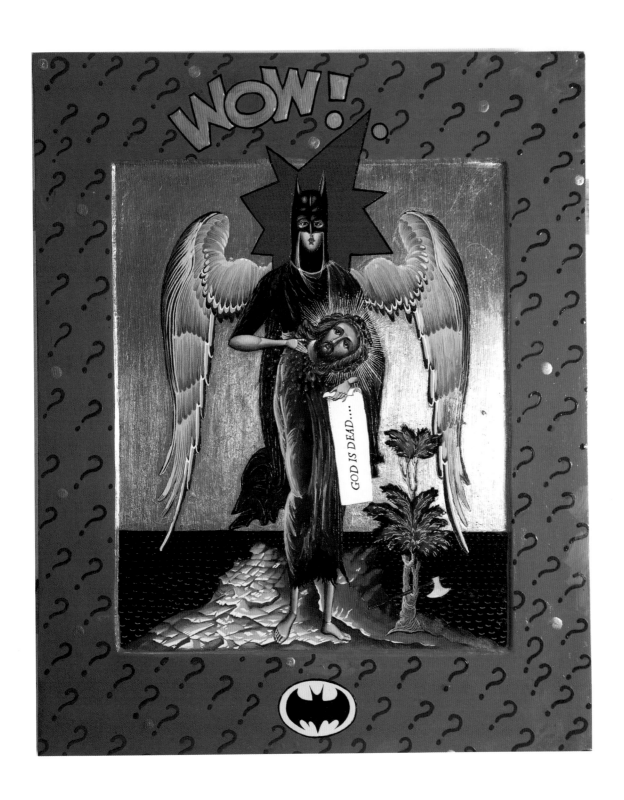

"God is Dead" oil on wood block, gold leaf 24"x19" 2010

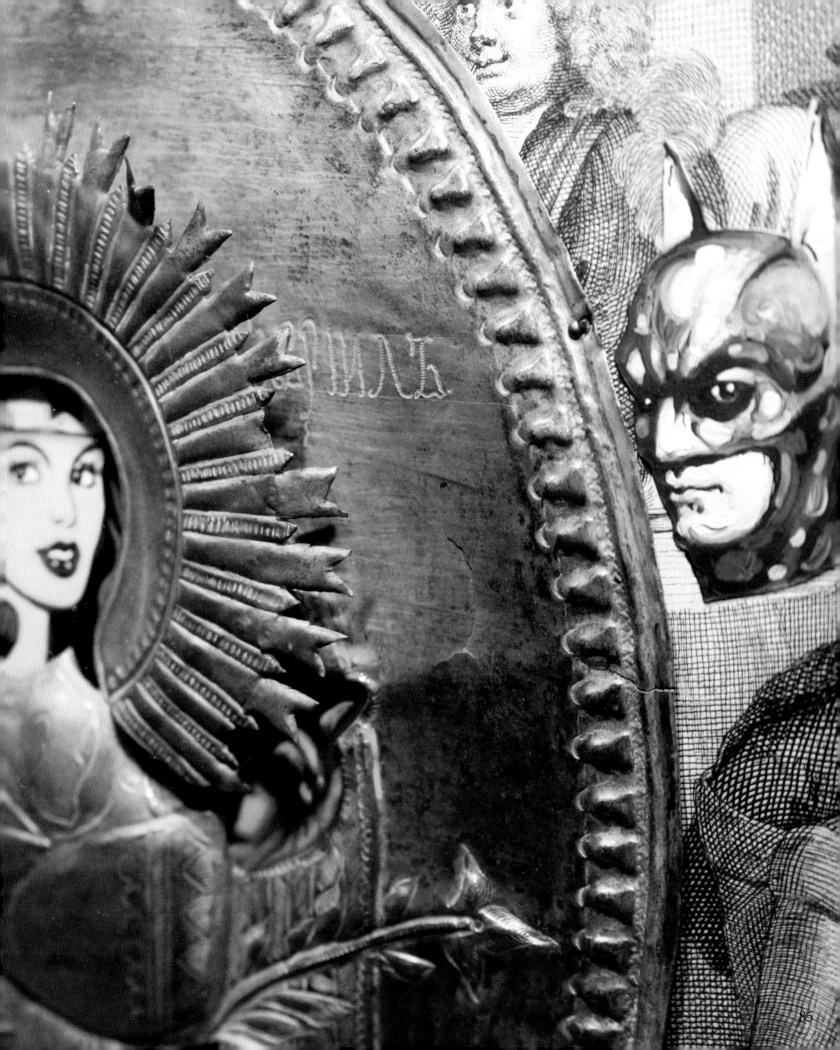

ROMANTIC CYNICISM

Formulated during the years he lived in the U.S.S.R., Popov's pet theory of "Romantic Cynicism" is a dualist, manichaean philosophy blending the romantic ideals of an eternally optimistic socialist utopia which was the Soviet Union with a personal sense of cynicism about life's drearier realities. "In the former U.S.S.R.," Valentin explains, "everyone was supposed to love one another and help one another achieve the common good, by each taking according to his needs and giving according to his abilities." Popov's large-scale painting First the Apple...Then Us, with its portrait-of-the-artist-as-worm emerging from a plump, ripe, red apple set in the foreground of a swampy prehistoric landscape, embodies the philosophy of Romantic Cynicism in its linkage of innocence and corruption, deceptive appearances, and twilight on the flimsy edifice of human "big ideas," hopes, and aspirations. Though his work often takes this form of comic surrealism, Popov is deadly serious about his vision of the world as a rotten apple with subversive spoilage gnawing at its core. His yin-yang view of the positive-negative nature of existence is reflected by artworks in which he links all manner of polar opposites to create what he calls "electric power circuits".

Perhaps no segment of Popov's oeuvre is more "romantically cynical" than his Saint Batman series. An episodic satire three years in the making, the series eventually involved more than 100 pieces. Loosely patterned after the life of Christ, Batman, in Popov's take, is a figure fashioned from fragments of popular mythology, religious lore, and created pseudohistory. Popov artworks have depicted Batman as Columbus, Batman in Egypt, Batman as the subject of invented 19th century-style engravings. Batman is considered as an immortal, seen in diverse parts of the globe in every century. Batman's roots are endlessly examined in a cycle of falsified religion and myth extending from his supposed childhood and youth through his ultimate crucifixion and possible resurrection. The series culminated with a performance piece in which Popov had himself crucified in a Batman costume, documented the event with the help of assistants, then made a plaster cast of the martyr from a living model. These tributes were followed by the issuance of a Batman death mask postage stamp. Popov explains his concept of Batman as a savior in a world where beliefs are so muddled and the presence of God is so elusive that people want to retreat into a childhood mentality where everything is good or evil, black or white. Batman comes to the rescue whenever he is summoned. A simplistic, cartoon icon from American pop culture, Popov combines Batman with the serious tradition of Christ, mankind's savior, and the whole concomitant tradition in art. Popov portrays Batman as Cupid leaving the bed of Psyche, Batman as Frederick the Great, Batman as the namesake of an engraving titled Heroism at the End of the 20th Century.

Popov is big on the notion of heroes and heroism. Not only is he enthralled with such recurring heroes of art history as Jesus, Saint George, Napoleon and Mickey Mouse, he is also concerned with the idea of the artist as hero and with masks, since masks are worn by everyone, heroes and artists most of all. Saint Batman is a sort of amalgam of all these obsessions, a masked crusader who is around to ensure that mankind keeps its moral balance. Popov's favorite philosopher is Nietzche, creator of the Superman concept as well as athe concept of a moral state of being "beyond good and evil." Popov's own preoccupation with morality is expressed in his huge, lushly painted mock Victorian moral allegories. Looking like vintage valentines or enamel cover art for turn-of-the-century candy tins, these feature

the seashore frolics of guileless, goo-goo-eyed children dressed in sailor suits and sunbonnets captioned with didactic inscriptions like "Nothing dries as fast as tears..." or "Familiarity breeds contempt...and children". In one, a boy is about to launch a toy boat in a real ocean; in another, Cupid has been shot in the back with one of his own arrows. Twisted parables paradoxically framed, they make for a weird fusion of early commercial advertising illustration and pure Dada.

Under Romantic Cynicism's rubric, any number of sins are subsumed. Among them are Love – Death, a black and white photograph of a linen panel where the word "Love" is lettered in black pigment opposite the slightly dessicated cadaver of a rat into whose fur has been snipped the word "Death" - a startling, if somewhat snide image. Tears is one of Popov's epic, large-scale oil and enamel on aluminum panels with linework which, though painted, has the effect of etching. Of an allegorical cast, it is a charming monumental portrait of a wavy-haired young girl in a frilly dress. The skin of her face, forehead, cheeks, arm, neck, and chest, is scribed with radiating lines following the natural anatomical curvature. Coloration ranges from pink to green, gray, blue and black, with touches of carmine and vermilion. Staggered across the picture plane are the words: "Nothing dries as fast as tears." Alongside this motto, there is a spray of tears – a sort of aerial squadron of dive-bombing red tears, resembling bloodrops, while across her chest, is a block of text suggestive of both a protective shibboleth and of a written judgment. The little girl has her hand upraised, with thumb and forefinger cocked and tilted towards her mouth in a curious gesture at once poignant and vaguely disturbing. Familiarity is another massive oil on aluminum allegory. This time, a boy wearing a sailor's suit, and a bonneted, red-headed girl are engaged in a quaint transaction. With one hand, the boy is holding a starfish, its underside up, exposing a gaping, vulva-like slit, at which he points with the index finger of his other hand. The girl gazes on the object with rapt fascination. An inscription reads: "Familiarity breeds contempt …and children." The boy is lined with brightly colored striations. The girl's face is overlain with a mesh of pointillist dots.

Yet another monumental oil on aluminum narrative is Are You My Scared Little Boy? In this instance, a young boy is attired in vintage plus fours and ankle-height, lace-up shoes. The knees of his plus fours billow over his leggings, jacket, cap and curls. Cradling a toy boat in his arms, he stands at the seashore amid a pile of smooth, waveworn rocks. As a cresting wave crashes on the beach and a swath of moonlight spreads across the surface of the ocean from the horizon to the foreground, what would ordinarily be the shining moon is, instead, seen to be a blushing rose blossom, on which the boy intently gazes. Next in the same series is Life. Calling to mind a Victorian valentine, a pair of curly-haired children stand chest-height at a draped table accompanied by a tufted stool. On top of the table rests an open book turned face down, and a large hourglass at whose spilling sands the children peer in fascination. Overhead, a legend reads: "Life". Lush, rich colors against a dark background give the scene a sort of gothic, gloomy feel. True masterpieces, solidly unified by a perfect balance of concept, mood, and execution, the Romantic Cynicism allegories, fashioned as they are with a quasi-folk or naïve art look blended with classical execution, radiate an altogether unique feel. The series continues with Le Colonial, in which another pair of children in vintage attire takes center stage. This time around, the girl is bonneted, gloved, and beruffled. The boy sports jacket, tie, and cap. The boy holds a snake whose tongue is darting in the direction of the girl. The girl has turned her back and shrinks away, half beguiled, half alarmed. The boy seems to want to impress or frighten the girl. He stares at her to gauge her reaction. The girl's eyes are riveted on the snake; it is the latter which has her rapt attention. Large,

solid color blocks inform this composition, with less of the abstract infilling and patternism characteristic of some of its siblings. The eyes of the children are especially expressive. The eye of the snake is dead, inert, like that of a lifeless prop. *Beautiful*…spotlights a youthful couple in eighteenth century garb standing for a portrait along with a shaggy goat. The dandified man, bewigged, leotarded, and sashed, flaunts a flowery purple tunic, a white chiffon tie at his throat. His moon-faced consort sparkles in her violet Marie-Antoinette-style dress, with a silk bow at her throat and a Voltaire-esque snood enveloping her hair. She holds a basket of multi-colored fruit. Even her pet goat has a scarlet flounce draped over its back. Behind the trio is a psychedelic riot of color - overarching blue-green foliage, a lot of gratuitous abstraction and some inexplicably hovering eyes. First the Apple, Then Us is a hilarious piece of pop surrealism. Within the prehistoric confines of a primordial swamp fringed with palm trees, reeds, and thickets, a curious drama unfolds: from the interior of a huge apple, emerges a caterpillar with a human head – that of the artist, Popov, himself. From the caterpillar-man emerges a speech balloon comprising of images of eyes. Above him hover four diaphanous bubbles containing ghostly symbols. First the Apple, Then Us is a wry confection, comical and Kafkaesque at the same time. Residuum epitomizes the principle of Romantic Cynicism. This mixed media piece is adorned with an ornate motif similar to a geometric tapestry, predominantly orange and gold in color, with an intricate, baroque design enclosing a small central square, dark to the point of nihility. The cynicism resides in the stark contrast between the romanticized, high-style matrix and the burnt-out kernel left over in the middle which repesents residuum. Equally romantically cynical is Hunger Never Saw Bad Bread, a sarcastic vignette presenting a partly outstretched, partly coiled snake in the act of clamping its jaws around a small rabbit. Fanning the snake's head are stress lines intended to underscore a moment of epiphany.

The entertaining conceit of "Romantic Cynicism" was first formulated by Popov in connection with a major exhibition in the mid-1990s. The concept is concerned with a "way of seeing," which reconciles the ideas, imagery, and atmosphere of dark romanticism with an attitude of arch irony. Whether it is considered a matter of romanticizing cynicism or cynicizing romanticism, the Romantic Cynicism project is a seriocomic extravaganza spoofing schools, styles, genres, and art movements themselves. Half in earnest, half in jest, Popov manages to integrate, under the intellectual umbrella of his satirical theoretical doctrine, a mélange of allegory, melodrama, Gothicism, sentimentalism, grotesquerie, and mock chivalry. But, beyond the enigma, mythomania, mimetic compulsion, curious, hybrid morphology, and all the other descriptives which might be applied to Popov's productions, two deeply important undercurrents sustain them. The first is the mystical impulse and the tendency to apotheosis which, in Russian art, is as deep-rooted as instinct. The other is the satirical streak. This dark humor, which figures so prominently in much of this artist's work, is deceptively playful: underlying the comic veneer, rest many layers of serious investigation. The chameleon from Kiev is nothing if not oblique and elliptical. Ultimately, his is a meta-art, in the sense that it is art about art, art about the process of artistic creation, art about art history, art about modernism in all its manifestations, art about metaphysical aspect. It is an art of infinite inflection.

Rick Gilbert

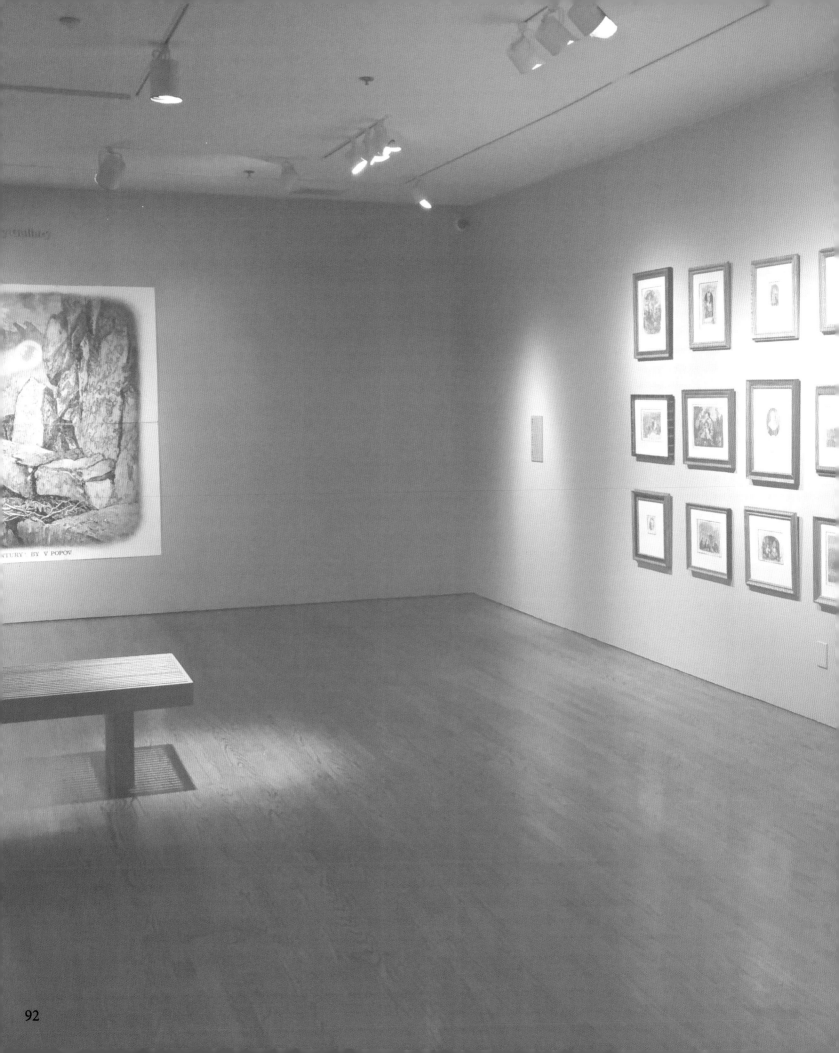

NTURY" BY V POPOV

92

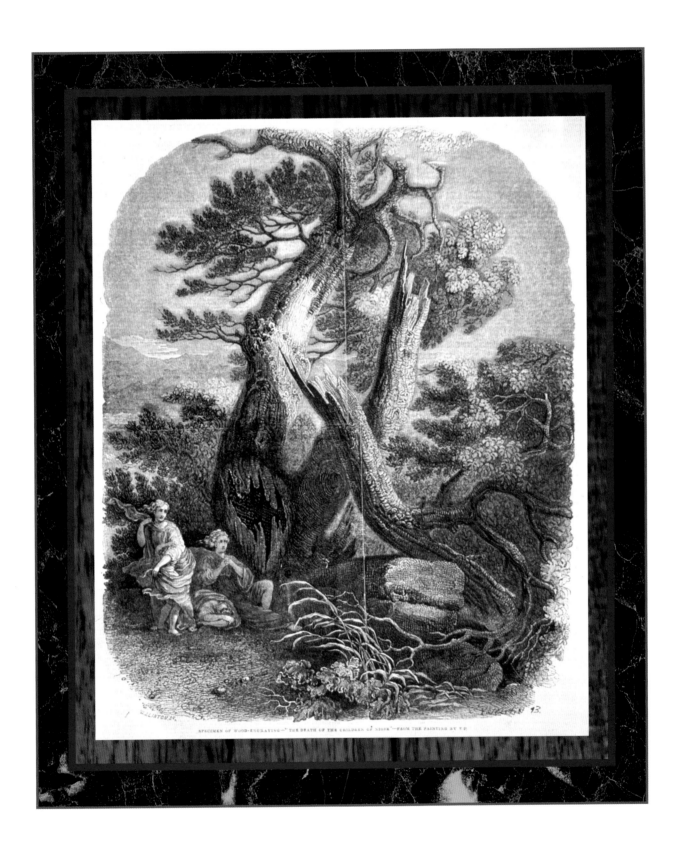

"Children of The Storm" acrylic and ink over nineteenth century engraving 21.5"x 17.75" (framed) 1993

"Batman Talking to the Peasants in the Field" acrylic and ink over nineteenth century engraving 17.625"x 20.75 (framed) 1993

"Sparkles in the Eyes" acrylic and ink over 19th century engraving 21.375"x 17.875" (framed) 1993

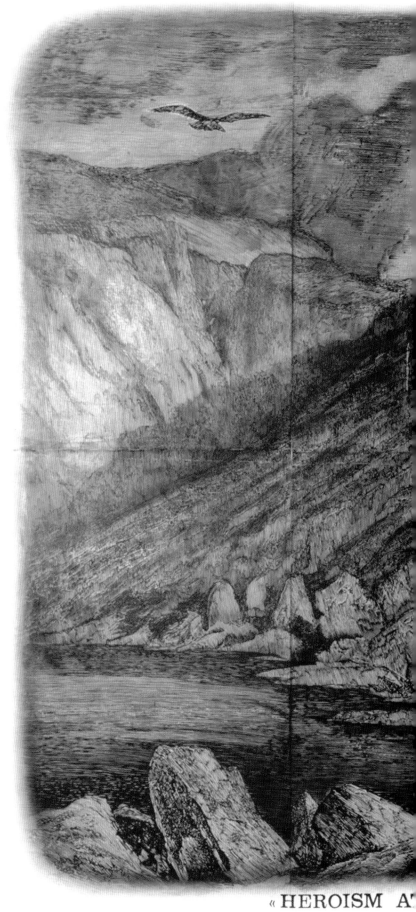

« HEROISM AT

"Heroism at the End of the 20th Century" acrylic on the paper with ceramic plates 85"x115" 1992-1993

104

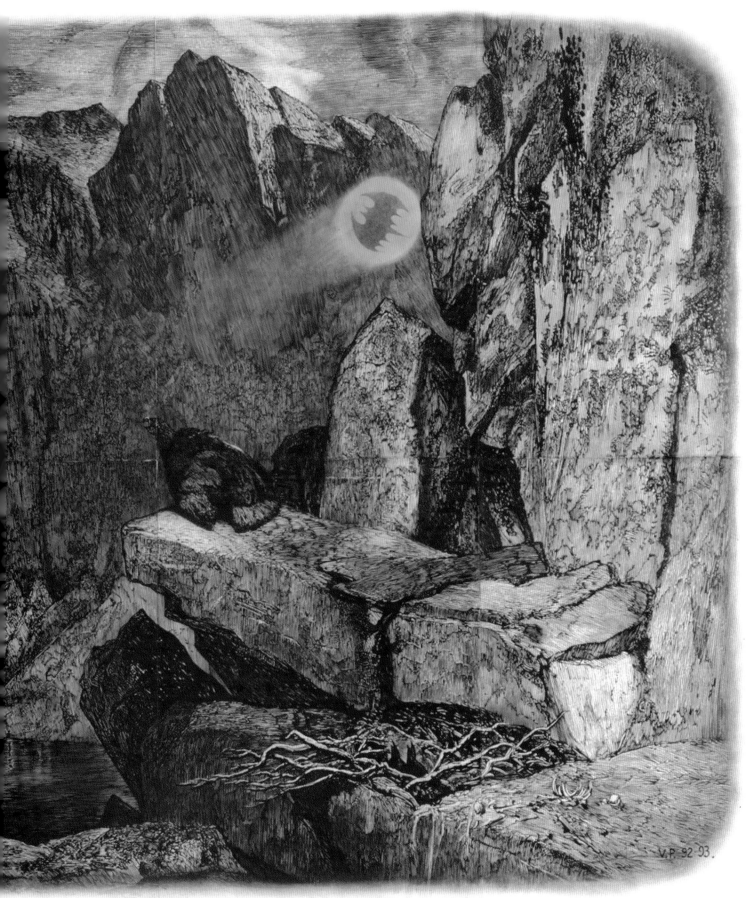

"HE END OF THE 20ᵗʰ CENTURY", BY V. POPOV

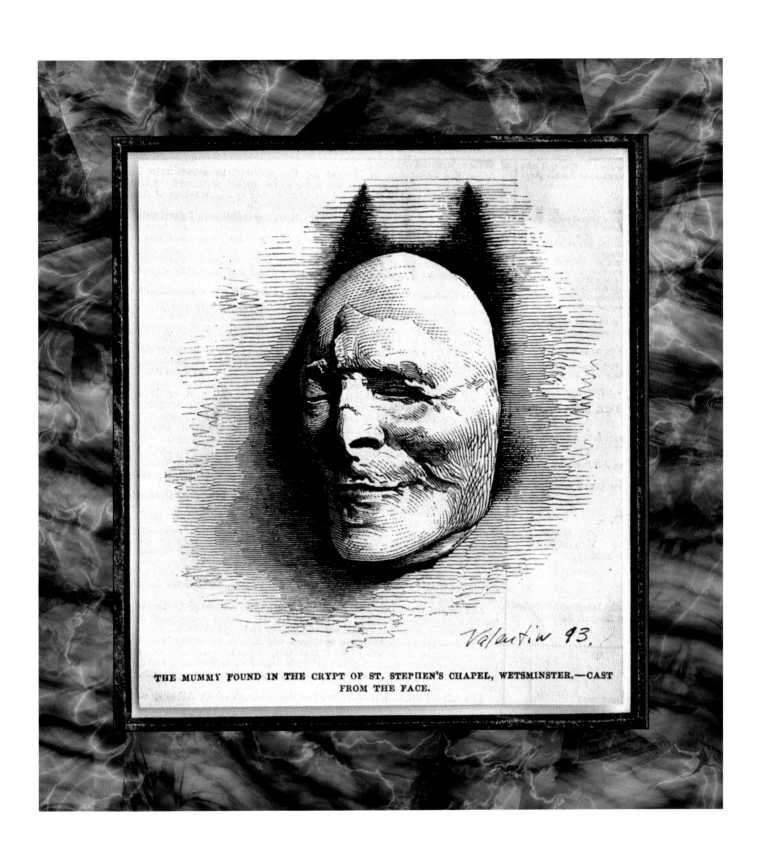

THE MUMMY FOUND IN THE CRYPT OF ST. STEPHEN'S CHAPEL, WETSMINSTER.—CAST
FROM THE FACE.

"Death Mask of the Batman" acrylic and ink over 19th century engraving 18.5"x 17.875" (framed) 1993

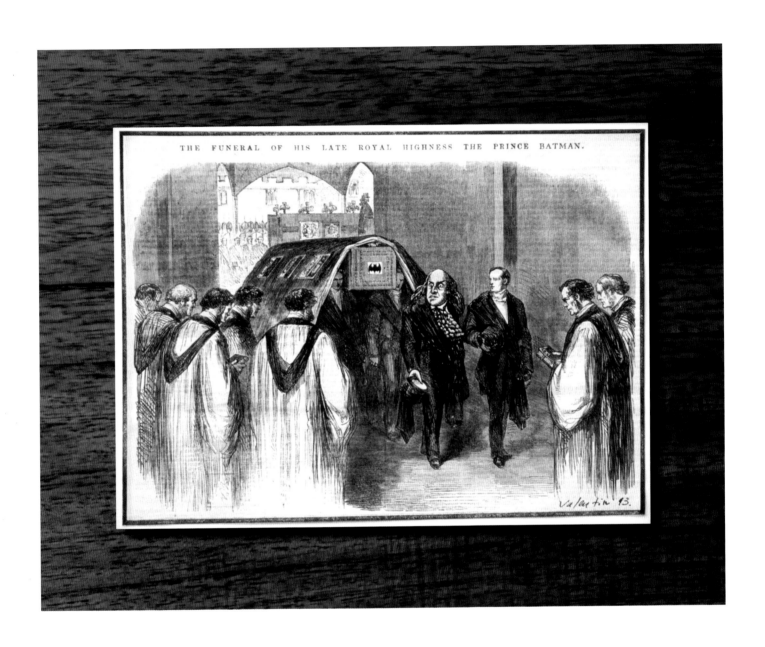

THE FUNERAL OF HIS LATE ROYAL HIGHNESS THE PRINCE BATMAN.

"Funeral of the Royal Prince Batman" acrylic and ink over 19th century engraving 16.5"x 9.25" (framed) 1993

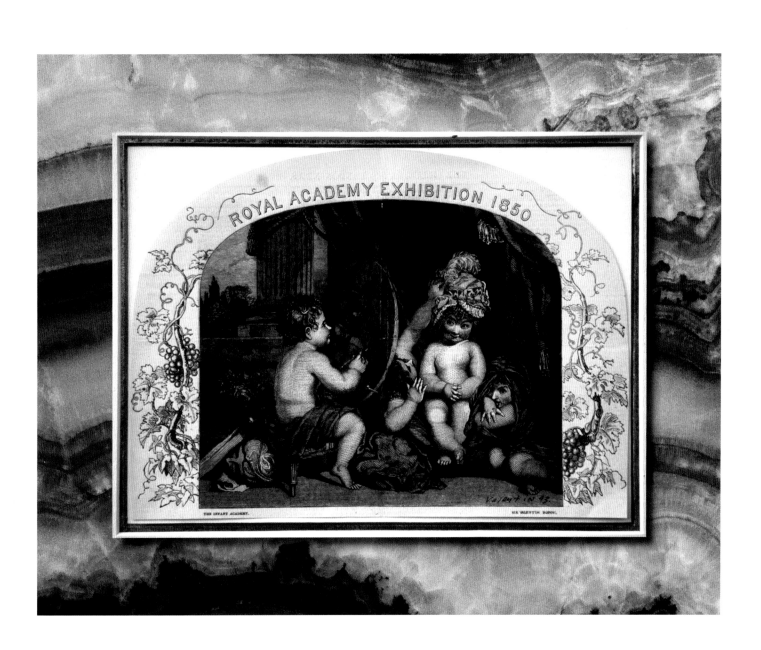

"Royal Academy" acrylic and ink over 19th century engraving 17.25"x 18.75" (framed) 1993

"AlfaBat" oil and mixed mediums on Masonite 31"x21.5 1994

112

St. Batman

Popov's tour de force St. Batman project represents a radical, headlong foray into the realm of all-stops-pulled post-modernism. The strongest suit in the Batman deck of cards is that of the Batman-as-icon ensemble, which consists of a large number of putative portraits and fictitious, fabricated, myth-pictures. Repetitively titled, several are called St. Batman; others Batman Icon. Among these creations, is Batman as cavalier, replete with ithyphallic metal codpiece and saber, in sixteenth century armor, booted and stirruped, on rampant horse with wild eyes and flaring nostrils, like one Meissonier's heroic portraits of Napoleon. Batman is hooded and sashed and bemedalled. His steed, caparisoned in crimson, looks like Fuseli's Nightmare. To the left, among an opening in the clouds, is the all-seeing eye of God; to the right, among the clouds, a cupid with bowstring drawn. Flaring across the sky, are a streaking comet and some mystical lettering; between the legs of Batman's mount, can be seen regiments of soldiers fording a river and marching over the undulating terrain on the far shore. In the right foreground, peeping from a leafy red shrub, ghostly faces can be made out in the low, vaporous clouds drifting above the far shore. In another tribute, a blue-gowned and veiled Madonna kisses a baby blue Batman who is hooded even in infancy. Baby Batman is seated on a satin pillow; Madonna, seated on a throne in front of a medieval tapestry and a pink and white polka dot curtain. On the sill in front of her rests a bunch of grapes. The thumb and forefinger or her free hand are joined in the symbol for piety. Just above her hand is a window through which appear the turrets of an Eastern Orthodox church with ramps running up its sides like a spiral ziggurat, and a huge white crane taking flight above it. One side of Madonna's throne bears a motto. Her cloak is festooned with tiny golden cranes. Around this central image is a border consisting of mystical symbols and scenes from the life of the saint: christening, ordination, marriage, beatification, death. In one oil on wood homage, a medieval emblem depicts Batman as St. George slaying the dragon, which a lady in the doorway of a castle keeps on a leash. In another icon with the same theme, St. Batman-St. George is surrounded by mystical symbols and coin-sized vignettes of important episodes from the saint's life, set off by the inscription "conjuratos".

Elsewhere amongst the false artifacts of the Batman suite are both a Batman Bust, consisting of a pen-and-ink drawing of a Roman bust fitted with a Batman hood and a Batman insignia shoulder clasp for its toga, and a full body St. Batman plaster cast of the crucified hero hung from a life-sized wooden cross.

The highly theatrical oil on aluminum *Early Morning* is a delicious take off on classical paintings of Cupid and Psyche. In the present variant, the nude Cupid-surrogate Batman vacates the bed of the sleeping Psyche, as the bat signal is flashed on the wall behind. A French academician couldn't have painted the bedclothes more exactingly. The luminous halo enveloping Psyche might have been limned by Rembrandt or one of the Mannerists. As if to add drama to the power of Batman's presence, speech balloons in the foreground read: "Have a belt on me, chum!"; and "Kapow!" With this single image, Popov not only conflates pop art and classicism, but digs at the anatomy of appropriationism by paraphrasing a famous predecessor in the same way Manet paraphrased, with

his *Dejeuner sur l'Herbe*, a well-known painting by Giorgio.

Still another set of related images in the *St. Batman* suite has to do with Batman's exploits or with the mythical history of his origins, lineage, deeds, and martyrdom. Heroism is a retouched vintage engraving showing an empty eagle's nest in a steep mountain crag, and the bat signal projected onto a cliff face in the background. The diptych *One Mistake* offers a vision of the ascended Batman, enhaloed by a blinding aureole radiating candy cane energy waves into the surrounding atmosphere while his foes cringe at his feet and cover themselves in fear. His speech balloon reads: "One mistake I could overlook, but not two!" The flip side of the diptych comprises two additional devotional panels featuring pseudoreligious and pseudohistorical diagrams relating to the development of St. Batman and his wondrous effects on the human race. On the left is a jumble of molecular models, protoplasm and genetic material; on the right a genealogical tree garlanded with cameos of Rembrandt, the Mona Lisa, Van Gogh and his ear, Romulus and Remus suckling at the teats of the wolf, Botticelli's Venus, Nefertiti, a tribe of Hottentots, etc. Elsewhere, in a perfect rendition of a crude ascension icon, Popov turns out Batman as a robed avatar with Jesus-length hair and beard, hooded, enhaloed, carrying a cross in one hand while clasping the hands of kneeling acolytes with the other.

Mock history at its most hilariously exorbitant takes the form of Penguin and Madonna Wedding, a triptych featuring a potpourri of historical figures, sacred emblems, religious symbols, and pseudogenealogical groups. The flip side of the piece details the wedding procession in an explosion of festive, celebratory detail. Batman History revels in a fusion of mock mythology and pop surrealism, wherein an angelic host forms a heavenly choir in the upper left-hand corner, to witness a mystical event: the conception of Batman. Below is a motley assembly of historical and mock historical personages: Pablo Picasso, Franz Hals, Napoleon Bonaparte, Ivan the Terrible, Tzar Nicolas, Alexander Borodin. To the right of the dignitaries is a manger scene in which is depicted a conventional, naturalistic steer; below it is a cubist steer and two of the Kings of the East in the guise of two different versions of the face of Vincent Van Gogh. Meanwhile, a Dutch cavalier, sword and musket at his side, sits with his lady among the plants in the foreground. Above the rustic manger, angels hover while mystical lettering squiggles across a sky irradiated by some unseen power, casting rays over undulating fields arrayed below towering arctic peaks. On the other side of the piece, a triptych, there is more pseudohistory and spoofed mythology: a zodiac, a Batman as the anatomical figure in Da Vinci's diagram of the golden mean; a Batman as Prometheus chained to a wall with his liver being pecked by vultures, a prehistoric landscape with dinosaurs, scenes of flying saucers over the Egyptian sphinx and over the Nile, explorers from the Age of Discovery claiming new lands, etc.

Then there are the *Batman* items based on manipulations of found art and adaptations of pre-existing folklore, popular beliefs, and religious tradition. Many of the associated pieces derive from modifications to found illustrations or send-ups of famous paintings. The *Library Academy*, for example, is a Victorian era engraving modified to include a portrait of Batman. *Joseph and Mary with Penguin Child* is a modified vintage painting with the head of an infant Penguin in place of that of the Christ child. *Mark of the Bat* is a modified vintage illustration revealing the bat sign

emblazoned on the trunk of a tree. Deserter is a modified vintage illustration showing Penguin as a confederate deserter wading through chest-high grass to surrender to federal troops. *Batman Funeral* is a modified vintage illustration of the Batman death mask embellished with a faint bat shadow. *Batlands* is a modified vintage illustration showing a circuit rider galloping over hostile terrain strewn with both the skull of unknown animal and a forlorn Batman skull.

Additional offshoots of the *St. Batman* project include a sketch book, with miscellaneous doodles and jottings; an *Alfabat* or alphabet consisting of invented bat letters corresponding to the conventional a through z; a thirteen-piece set of matruschkas or Russian nesting dolls of diminishing size, each with a black hood, mask and body suit, and each with a different symbol or insignia held in front of its chest; a Chess showing a play-by-play diagram of a chess board with a Batman symbol to denote a playing piece; and, finally, a performance titled *Batman Crucifixion* consisting of a series of photos documenting the enactment of a paraphrase of the crucifixion of Christ with a nude, hooded Batman 1) bearing his cross down a road or path 2) digging a hole in which to prop the heavy wooden cross 3) fastened to the cross by two liveried footmen 4) successfully crucified 5) hanging from his cross as two footmen toast the occasion 6) absent from a barren cross seen at dusk, devoid of victim.

Rick Gilbert

An Iconic World View

Growing up in San Francisco Chinatown in the 1950s and 60s, my whole world was encased in an exotic frame of 15 square city blocks. Our parents were graduate students in international relations and applied mathematics; but they were exiled at UC Berkeley when the communists took over their homeland. Unable to return, they married, struggled, and started an herbal medicine shop in Chinatown. We were surrounded by the talismans and practices of a culture left behind. My understanding of American society was gleaned from what I learned at school, at the library, American Bandstand and from the pages of comic books.

Our parents allowed my brothers and me to make a weekly pilgrimage to the dingy comic book store a half block away from our family store after all homework was done, and only if we had finished practicing piano. What wonderful hours we spent there, sitting Indian-style on the floor of that temple of comic books, pretending to be Archie, Jughead, Richie Rich, Superman or Diana the Amazon Princess, and wondering what it would be like to have x-ray vision or the ability to fly. The shopkeeper was not terribly friendly unless she knew that we had the money to buy the comics we were reading. She would give the bum's rush to the kids who were freeloading with no intention to buy. But my brothers and I each had weekly allowance money to spend on our precious comics, so we were welcome to stay on and read.

We were obsessed with the amazing stories of DC Comics' characters: Superman, Batman, Wonder Woman and Aquaman. They were so heroic, with stories harking back to faraway lands; and they possessed superpowers that were only limited by one's lack of imagination. We were in heaven. We didn't fully appreciate our attraction to these superheroes and their stories, but they spoke to us.

It is only decades later upon encountering Valentin Popov's marvelous Ironic Icons that I have come to reflect upon how much these comic book heroes actually echoed certain perspectives in our own immigrant lives. Jor-El and Lara were diplomats and scholars from the doomed planet Krypton. They made huge personal sacrifices to send their son Kal-El to planet earth so he could survive. There, he lived in Smallville while assimilating into mainstream American society. Kal-El took on the persona of Clark Kent, seemingly meek and mild, while hiding his tremendous superpowers from those around him. He needed to fit in to survive. He not only survived but thrived, becoming Superman defending truth, justice and the American way. Similarly, our parents had lost lives of privilege and distinction in China and struggled to give their children better lives in a new country. We were taught to blend in and not to draw attention to ourselves to avoid discrimination or attacks. It was better to keep heads down, work hard, and develop exceptional knowledge and skills to work our way up to a better life. This was the American way, the American dream.

Interestingly, Bruce Wayne came from a world of privilege, but developed an extreme personal sense of justice. Despite his wealth, he was beset with darkness and tragedy in his young life which inspired him to secretly develop his physical and mental prowess to become Batman. He was driven to right the wrongs and fight the evil that destroyed his parents. His solution was to take problems

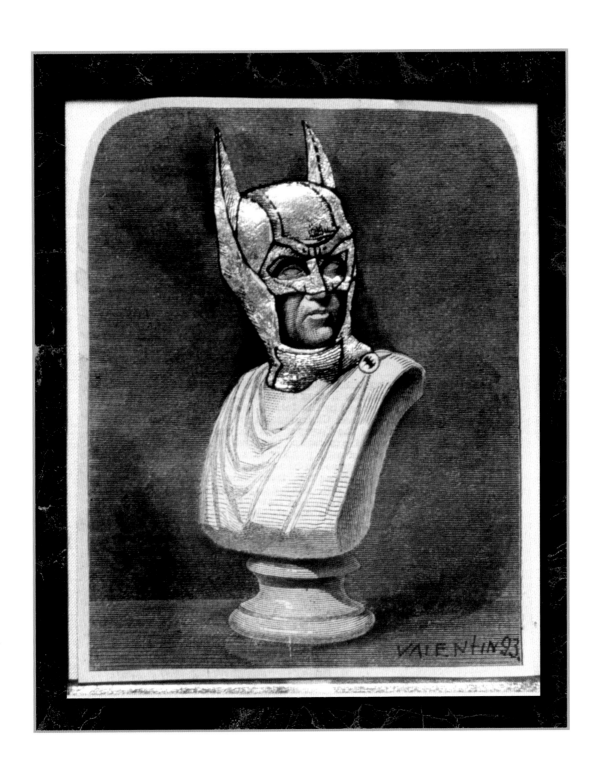

"Gold Mask" acrylic and ink over 19th century engraving 17.875"x 13.375" (framed) 1993

into his own hands and fix them for the betterment of the citizens of Gotham City. Some claim that his power lies in his sense of vengeance, but I prefer to think of it as inspiration to implement change. He gave us a real sense of right and wrong, a sense of power over adversity. Living in an insular community, the Chinese in San Francisco had to fight to stay in Chinatown against a backdrop of bans against Chinese in schools and hospitals, hysterical cries against us as the "yellow peril", the Exclusion Act, and vigilantism. We fought over a century to gain political recognition and earn our "piece of the American pie", the right to an education, social justice, housing, and health care. That struggle remains, and we are still righting socio-economic wrongs and continually battling xenophobia for the good of our community.

As a young girl in San Francisco in the 60s, I felt that times were indeed "a-changin'". My world was expanding beyond the fifteen city blocks I called home. We were no longer expected to be only housewives and submissive "little women." My all-girl Catholic high school encouraged us to excel in arts, sciences, sports, literature, and political debate. It was the era of Jackie Kennedy, Patsy Mink, Gloria Steinem, Nina Simone and Billie Jean King. We felt empowered to become whatever we wanted. But this was not a singular wave of feminism in American history. Interestingly, Wonder Woman emerged from the DC Universe in 1941, just when women were leaving their kitchens to enter the work force to keep the war effort going. It was a time when the image of Rosie the Riveter building ships and making ammunition was emblazoned into our consciousness; and DC's Diana, Princess of the Amazons, spurred American children to think of us as Army nurses and WAVES. Nearly seventy years later, Diana Prince continues to thrive in today's movies and comic books as an astronaut, a Pentagon military intelligence officer, and a fashion maven to inspire a new generation of women warriors. And before that, the Suffragettes fought for and won the right for women to vote. But the legend of the amazons is much older than the 1960s, 1940s, or even the 1900s, deriving from Greek mythology with a race of women warriors appearing in pottery, stories and artwork as early as 760 – 490 BCE. These mythical women fought and won ancient wars, changed history, established cities, built temples and their own religious belief system. Clearly, the power of women was recognized for centuries before DC Comics' incarnation of Diana and certainly deserving of iconic stature.

Although I stopped reading comic books some time ago, I rediscovered my childhood heroes in Valentin's brilliant Icons. They give me joy and remind me of an innocent time when I was learning to become a person of substance. Superman, Batman, Wonder Woman are all appropriately and beautifully enshrined in golden or silver frames, bejeweled, and befitting their place in our culture. Some say that these secular cartoon heroes supplant our religious icons. This may be overstating the case, but they teach us to seek the truth, to strive, and reinforce our morality. They remind us to choose right over wrong. They remind us that although our powers may not be "super," we all have skills, talents and strengths that sustain us in times of trouble. We see ourselves reflected back in the struggles these heroes endured, and hope to attain the success they embody as super men and women in the context of our own existence. They are important reminders, especially in these dark times. They are the embodiment of our hope, and the enshrinement of the virtue we strive for.

Amy Chung
February 11, 2020

THE WAR IN AMERICA :—A CONFEDERATE DESERTER COMING INTO THE FEDERAL LINES AT MUNSON'S HILL.—FROM A SKETCH BY OUR SPECIAL ARTIST.—VALENTIN POPOV.

"War in America" acrylic and ink over 19th century engraving 15.75"x 17.75" (framed) 1993

ICONIC IRONY

Andrei Ustinov
(San Francisco)

What's known is known to a few
Aristotélēs

O Superman. O Judge. O Mom and Dad.
Laurie Anderson

When it comes to Valentin Popov's *Ironic Icons* a viewer is bound to start with basic inquiries, as if asking Mom and Dad simple questions like "what? how? why?"

"What" is a rather trivial subject—superheroes from American comic books. It is an unconventional angle of Popov's vision that transforms them into the icons—wooden panels which are painted with primary dyes mixed with an egg white, yet gilded with gold leaf and sometimes precious stones to convey the sappiness of their pretentious solemnity. He further drowns his protagonists in an absurd pomposity with all the weight of heavy gilded casings, known as *oklads*. This is how he equalizes superheroes and saints.

You recognize how they look, wearing a nimbus and a cassock, or a mask and a cape. You remember that someone somewhere sought their assistance. You know their monikers *St. Christopher* and *Santa Barbara*, *Superman* and *Superwoman*. Perhaps, you may even recall their full names *Reprobus* or *Peter Parker*. However, unless you are deep into exegesis or a comics nerd, you have absolutely no idea what they actually did, how their lives, whether fictitious or imagined, have unfolded.

In this regard, Popov will not help you either, but he may give some hints by the way of *pentimento*. Here he leaves a graffiti of the *Joker's* demented smile, there he drops *Batman's* skull on the path of *The Equestrian*, or simply slams baby *Penguin* in the caring hands of some unsuspecting, and definitely not "holy" family. He utterly refuses to follow a very linear and, as a rule, pretty straightforward story of any superhero. Actually, Popov is affronted by the very narrative of comics, where every literary plot twist is highly predictable, and artistic devices used in storytelling are limited to either BANG! or BOOM!

In the *DC Universe* Batman rides to the rescue using crazy means of transportation, armed to the teeth with various accoutrements, proudly wearing a cape and projecting a piercing gaze through the holes in his jet black mask. In Popov's series of works across a variety of media, he represents different facets of his private obsession with *Saint Bat* (check out his email address!) Popov defrocks the caped crusader, but keeps his mask with pointy ears that replace a halo, and fervently succumbs to a peripatetic climb from Woodside to Calvary that concludes with an anticipated Crucifixion.

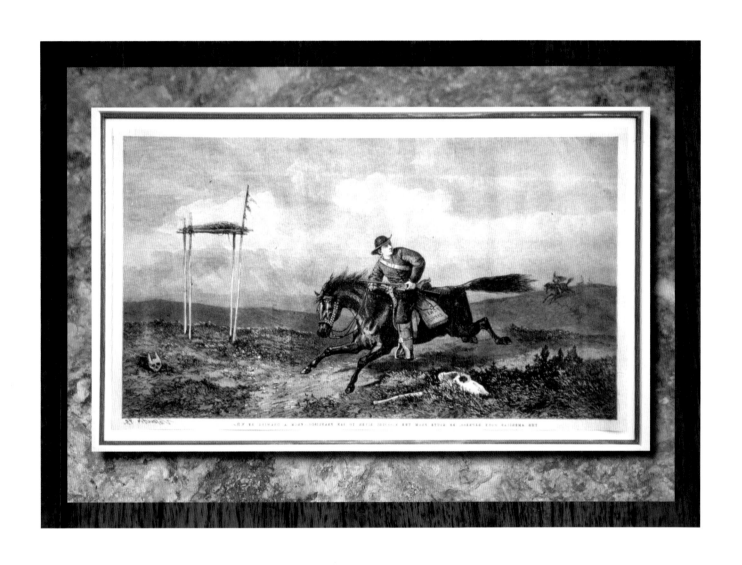

"Equestrian" acrylic and ink over 19th century engraving 17.625"x 21.25" (framed) 1993

Batman's major advantage lies with cool gadgets, always readily accessible to him yet for others representing nothing more than the stuff that dreams are made of. So, for his *St. Bat* Popov creates a level playing field—a chessboard. As we have the white rook on c5, and the white queen on h2, Black is almost in zugzwang. However, the dark knight lands on d4, prevents an apparent surrender of the black king, and saves the day. HOORAY!

"How" is achieved as a matter of Popov's craft. For an artist to embrace so many forms and genres including drawings, paintings, miniatures, photographs, and direct them toward a fulfillment of a singular theme might seem manic indeed. Also, one should not overlook sculpture, as that black and white *Batman* hanging from Brunelleschi's cross will surely look intimidating enough in any chosen establishment.

While superheroes depend on having a wild array of dreamt up contraptions at their disposal, Popov's tools although diverse are quite real. He exercises his artistic authority in mastering pencils and pens, chalk and coal, acrylics and oils. An avid admirer of Alexander Dumas, Popov is like one of the musketeers, although he exchanged a plumaged hat for a palette, and a sword for a brush of just the right shape and size for that particular moment of inspiration.

Furthermore, Popov's magnanimous tribute to all superheroes: *Batman, Superman, Spiderman*, et al., achieves its purpose by undermining the very foundation they stand upon. These imaginary superfriends to diminutive humankind always take themselves very, very seriously. They are always so grave and staid throughout their stories that are so inconsequential.

"Why so serious?" A simple answer is that the comics are absolutely immune to irony, while their protagonists are loaded with fallacy that looms on every page. Popov's art is categorically subversive to them, because he uses *Irony* as the only tool strong enough to expose their paltriness and triteness. *Irony*, as we know allows to challenge any work of art for its ostentatious seriousness and falsehood.

We learned that from Aristotélēs and the second part of his *De Poetica*, granted, lost for us in antiquity, but reconstructed in its major themes by Umberto Eco in his encyclopedic *The Name of the Rose*. Irony has a magic touch when it comes to overthrowing wiredrawn somberness, and exposes it as something petty and banal. It is *Irony* that elevates Popov's craft, bringing it to another plane, higher and higher, where angels are soaring.

Angels are truly more credible than saints and superheroes. I can easily believe in *Damiel* and *Cassiel* watching over days going by and by from the top of Brandenburg Gate in Wim Wenders' subtly romantic *Der Himmel über Berlin*. After all, *Irony* cannot exist without being romantic.

Angels however, always bring a storm, maybe even a tempest. This is what Walter Benjamin, a rapt and observant scholar of angels' behavior, wrote in his *Über den Begriff der Geschichte* (1940), while commenting on Paul Klee's diffident *Angelus Novus*:

> This is how one pictures the angel of history. His face is turned toward the past. Where we

"Birth of Penguin in Egypt" acrylic and ink over 19th century engraving 18.125"x 21.5" (framed) 1993

perceive a chain of events, he sees one single catastrophe which keeps piling wreckage upon wreckage and hurls it in front of his feet. The angel would like to stay, awaken the dead, and make whole what has been smashed. But a storm is blowing from paradise; it has got caught in his wings with such violence that the angel can no longer close them. The storm irresistibly propels him into the future to which his back is turned, while the pile of debris before him grows skyward. This storm is what we call progress.

Paul Klee, *Angelus Novus* 1920

And what Laurie Anderson, the preeminent performance artist, paraphrased so beautifully in her *The Dream Before* (1989):

> She said: What is history?
> And he said: History is an angel
> Being blown backwards into the future
> He said: History is a pile of debris,
> And the angel wants to go back and fix things,
> To repair the things that have been broken.
> But there is a storm blowing from paradise
> And the storm keeps blowing the angel
> Backwards into the future.
> And this storm, this storm
> Is called
> Progress.

Here, in *Ironic Icons*, Popov comes across as a supplicant to a higher power of art. And all the superheroes canonized by him with *Iconic Irony*, fly to the rescue with all the veracity and valor only they can graciously grant.

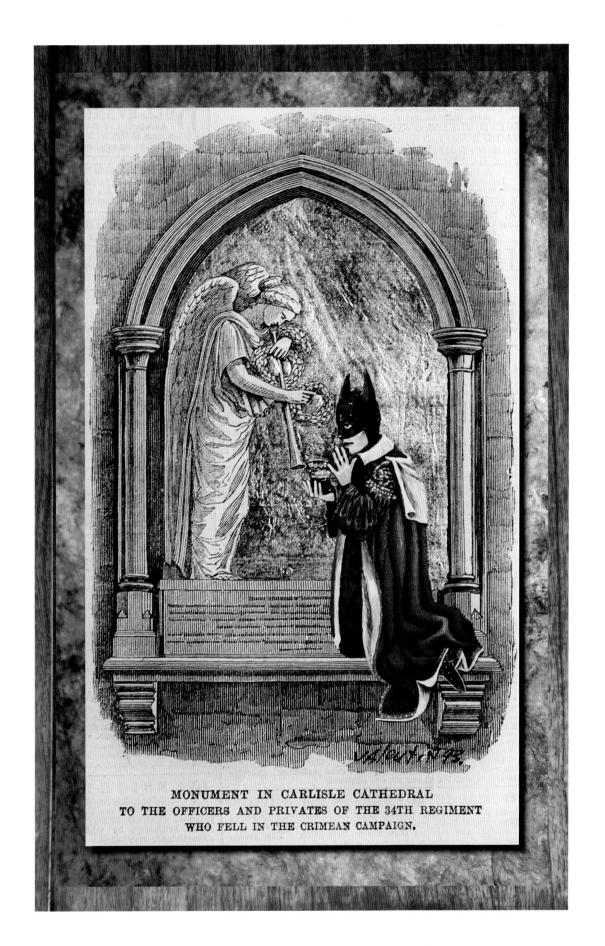

MONUMENT IN CARLISLE CATHEDRAL
TO THE OFFICERS AND PRIVATES OF THE 34TH REGIMENT
WHO FELL IN THE CRIMEAN CAMPAIGN.

"Red Dress" acrylic and ink over 19th century engraving 17"x 16.5" (framed) 1993

CONCEPTUAL COLLABORATION
Across Centuries, Cultures, and Distances

Valentin Popov's evolution as an artist is an amalgamation of his stringent fine art training in the Ukraine and his absorption of modern popular culture in the United States, where he has resided as a citizen for the past twenty years.

In his mature work, Popov has always been obsessed with the notion of the superhero both as savior but at times also sacrificial victim leading to sainthood. There is humor and irony in his work, but beneath that seeming superficiality is a seriousness of purpose. We live in an uncertain world that yearns for heroes to rescue us from the terrors that surround us on a daily basis, whether it presents itself as crime, poverty, or a deadly virus.

In recent years Popov, in his infrequent travels back to Ukraine, enlisted associates to seek out and acquire at flea markets, discarded *oklads* - sheet metal coverings that once framed old religious icons. Since 2000, Popov has utilized these authentic *oklads* in framing his painted recreations of icons depicting his repertoire of modern comic book superheroes.

As Popov became more absorbed in the history of religious icons in his native Ukraine, he became aware that it was not a lost art, but that there was a whole school of contemporary artisans who were honoring the past by continuing the tradition of making meticulous icon replicas.

Always open to new conceptual ideas and challenges, Popov engaged his childhood friend, Serhii Shyshlovskyi, with a proposal: could some of those Ukrainian artisans be open to working with him, utilizing his pop culture imagery, in employing their centuries-old skills to make stunning new collaborative "icons"? The answer was affirmative, as can be witnessed by the stunning work that resulted

The artisans Elena Bublik, Liudmila Udovitchenko, and Lidia Yashenko (all women) come from the Ukrainian cities of Dniper and Poltava. Called the "Serhii Shyshlovskyi Group" after Popov's boyhood friend, they go by their art names "Light", "Fate", and "Lily". The evolution of each work is not merely a copy of an earlier work, but a painstaking original process between Popov and these artisans thousands of miles away.

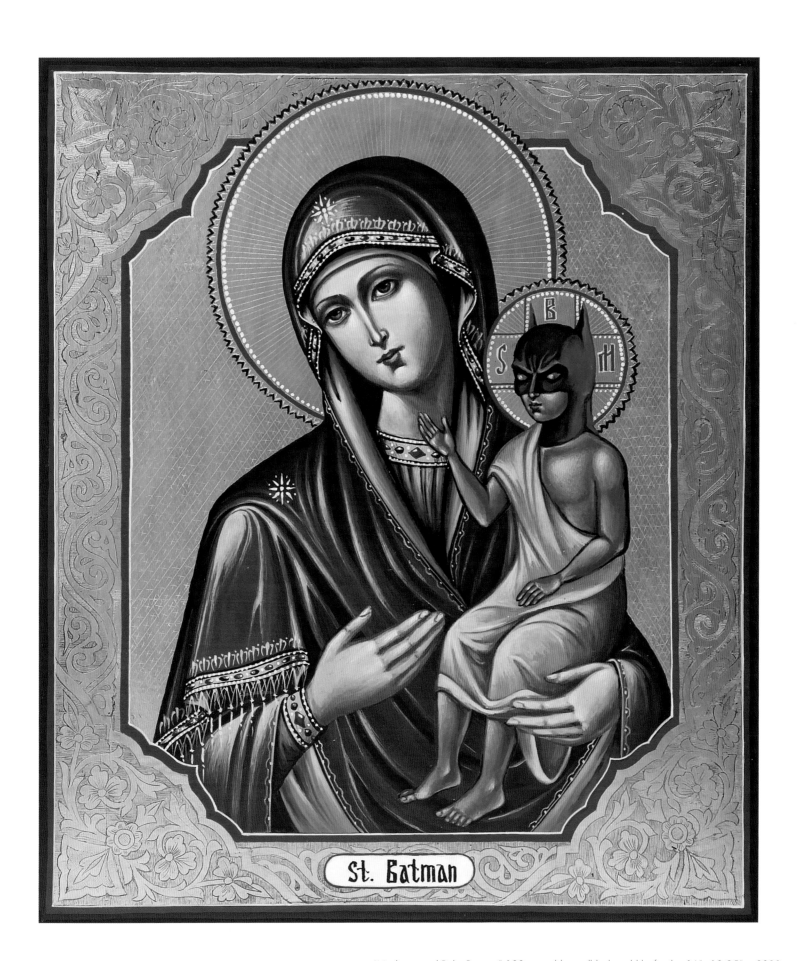

St. Batman

"Madonna and Baby Batman" 100 year old woodblock, gold leaf, oil 16"x 13.25" 2020

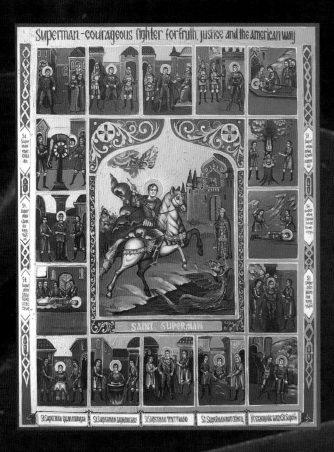

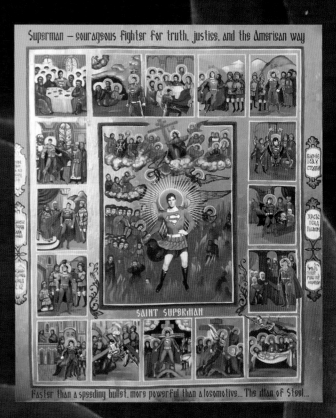

Designs and icons made in collaboration with the finest artisans in the Ukraine.

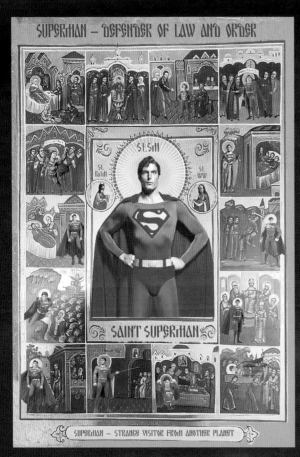

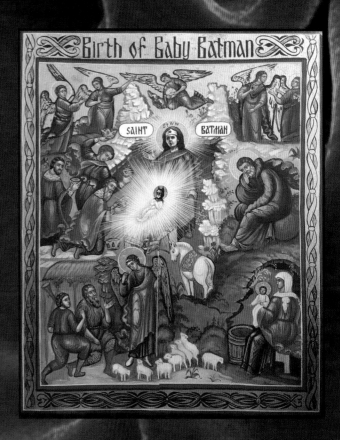

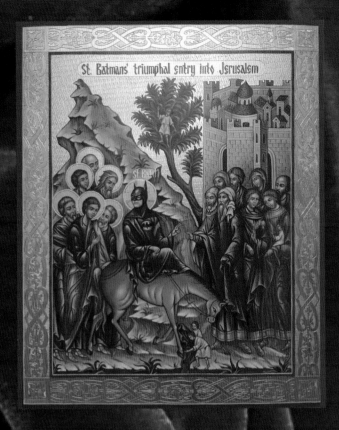

St. Batmans' triumphal entry into Jerusalem

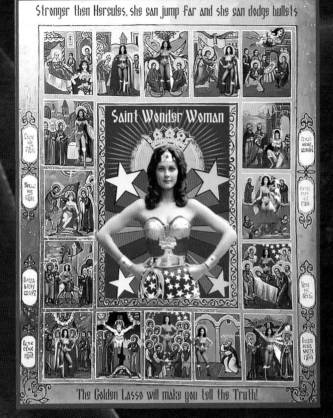

Stronger then Hercules, she can jump far and she can dodge bullets

Saint Wonder Woman

The Golden Lasso will make you tell the Truth!

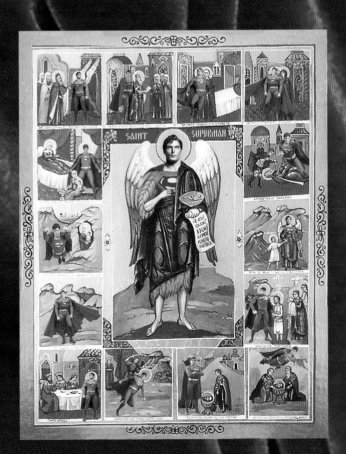

SAINT SUPERMAN

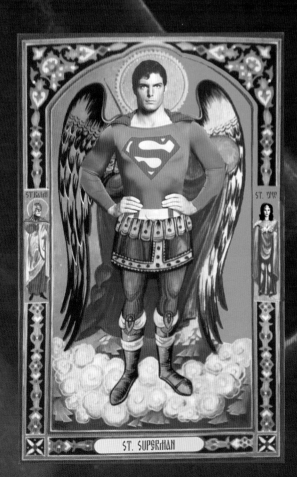

ST. SUPERMAN

First Popov produces detailed sketches on his computer, referencing ancient Christian iconography. He then substitutes and refines his pop culture subject matter until a finished and unified composition is completed. That "model" is then sent to the Ukraine where, under the overall supervision of his friend Shyshlovskyi, Popov's conceptual vision is turned into reality. The whole process is a coordinated team effort as each of the artisans utilizes her particular skills. One would do the gesso carving and gold leaf; another would paint the faces; and the third would add the clothing, lettering, and backgrounds. Each artisan's specialty is necessary to create a unified whole.

For Popov, his art went from concept to collaboration to completion, from his adoptive country to his country of origin, then back again.

He has acknowledged the craftmanship in Ukraine that has kept the icon tradition alive for generations. In employing, directing and inspiring these fine artisans, Valentin Popov has reimagined icons with the startling originality of his modern vision.

Robert Flynn Johnson
Curator Emeritus
Achenbach Foundation for Graphic Arts
Fine Arts Museums of San Francisco

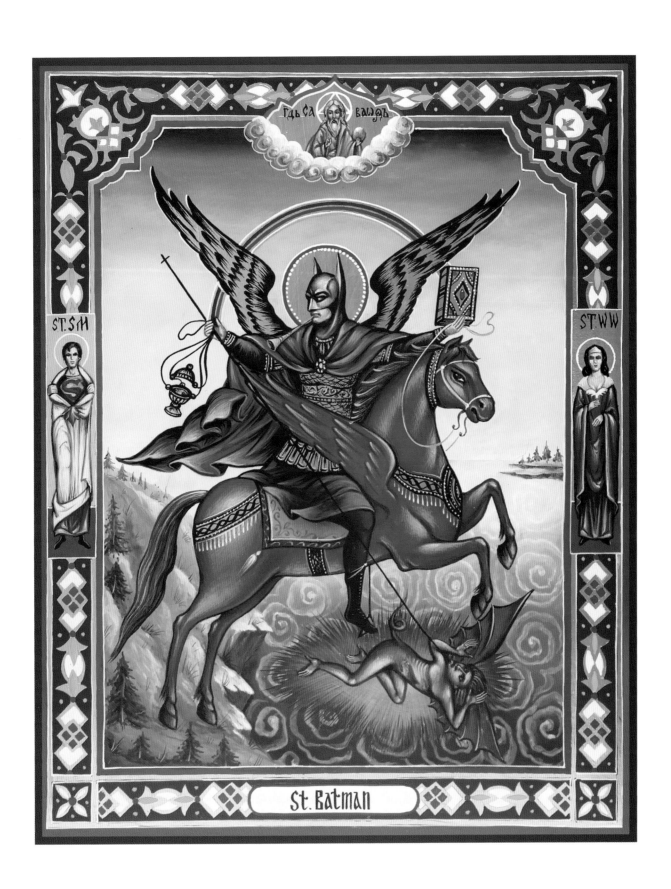

ГДЬ СА ВАШДЪ

ST. SM

ST. WW

St. Batman

"Saint Batman" 100 year old woodblock, gold leaf, oil 17"x13" 2020

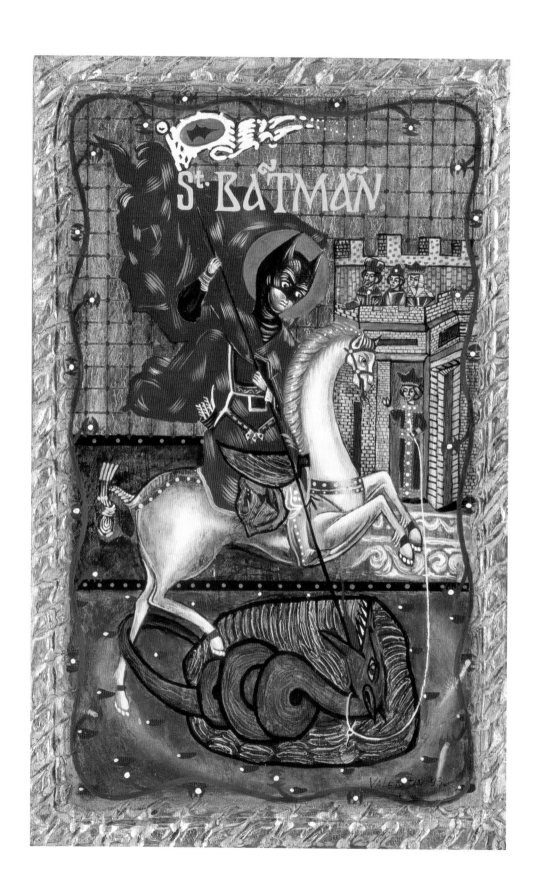

"Batman Icon" oil on gilded wood block 16"x10" 1993

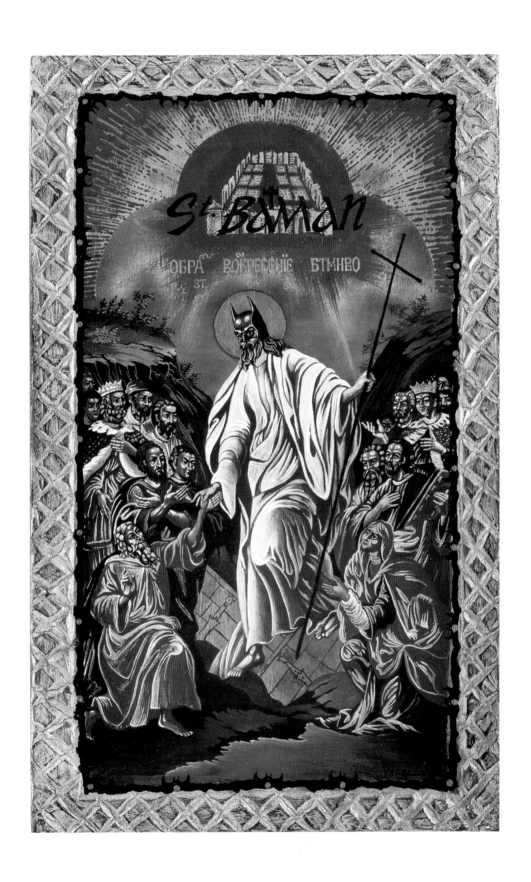

"Batman Icon" oil on gilded wood block 16"x10" 1993

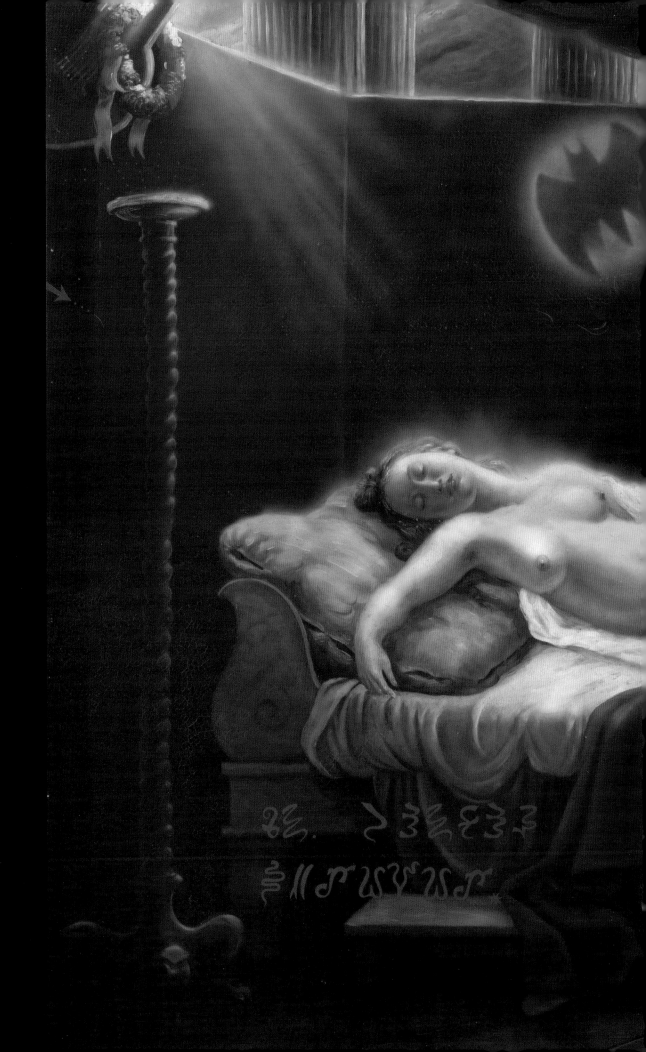

"Early Morning"
oil on aluminum
59"x 87" 1998

Batmen in the Belltower:
Art as Secular Religion

An important additional aspect of the Ironic Icons project is the light it obliquely throws on the notion, much bruited about since the latter part of the twentieth century, that art has assumed a cult-like status and, after a fashion, has supplanted religion as a source of spiritual sustenance. Many commentators have offered their thoughts on this subject. "Art is in some respects similar to religion," observes Dwight Furrow. "It invests activities and things with significance, invites us to look beyond ourselves, sometimes promises contact with something more real than ordinary life, and can sometimes involve rituals."

In considering the blurring of ecclesiastical and secular space, and the transformation of galleries and museums into temples of culture, Jonathan Koestle-Cate notes that, "it has been claimed that cathedrals are one of the few places where works of art can get a good showing. Conversely, it has been asserted that the sterile precinct of the 'white cube gallery' is not only 'the perfect place for art' but has 'something almost of the sacred about it,' such that, like a cathedral or chapel, it 'resonates.' With what does it resonate and why should it be the perfect place? It soon becomes clear that it is 'the sacredness of the space' that resonates, 'hinted' at by its uncluttered emptiness, which bespeaks both a 'spirituality of Modernism' and 'a Puritan spirituality' which 'does away with inessentials' and provides a visually purified space so utterly removed from the visual paraphernalia of the world outside its walls.

Some observers have drawn a parallel between the medieval church and the sanctified space of the gallery. The repositioning of religious gravitas within the bare walls of the modern white cube gallery is a familiar move, inaugurated by a Modernist creed which itself assumed the aura of spiritual authority for an art that no longer had need of any religious trappings to imbue it with a sense of otherworldliness. As Simon Morley once noted, "the art gallery or museum appropriates aspects of religious symbolism, but replaces an uncluttered contemplation of the transcendent God by a cool and detached contemplation of the artwork. There are implicit assumptions that sacred and profane, religious and secular, need no longer be seen as antithetical in the light of contemporary crossovers: the gallery has been sacralized by the continuing presence of religious concerns and the church has been colonized by the secular. It has been suggested that while the sacred and secular have historically been separate, artists are amongst those who can disturb this division and encourage a greater parity of, or communion between, the two. In other words, we should question the conventional wisdom that would place religious art and secular art in different and opposing camps. This would seem to allow more latitude for diverse experiences of sacredness."

"I would compare the influence of art with that of religion," asserts Dewitt H. Parker. "The effect of religion upon conduct is partly due to the supernatural sanctions which it attaches to the stories of the gods. Now these stories have an existence in the imagination precisely comparable to that of works of art, and their influence upon sentiment is of exactly the same order."

During one recent museum exhibition of Greek icons, staff quickly became aware that museum patrons were kissing the plexiglass cases in which the icons were displayed. "Every day, after the exhibition closed, somebody

would have to go through with Windex and get the kissing off this plexiglas," said a museum representative. "And not just lipstick; men did it too."

"Despite severing the religious artworks from the sacred environments for which they may have been commissioned and created, museums still forge sacred spaces in their exhibition halls when they display certain types of art. In the aforementioned exhibit, for example, the curator kept the scale intimate and the galleries dark to recreate the aura of a 12th or 13th century Byzantine church. In so doing, he may have answered the question: 'Can curators take on priestly activities?' Museum visitors can also 'remake the sacred within a museum,' according to one official, who has seen Christians and Muslims gaze at relics – whether a splinter from the True Cross or a hair from the Prophet Muhammad's beard – in a museum setting and pray before them. 'They are making it a sacred thing again,' he said. This arrangement ought to suit museums fine, since they want visitors to be awed by great works of art: 'The museum might call itself secular, but they are engaged in highly sacred work,' he said. 'It's interesting to see the extent to which increasingly museums, including fine art museums, are beginning to tolerate, or even perhaps to encourage, the veneration of certain objects in their displays.'"

"We have in our culture conflated the aesthetic and the sacred, which is why the art museum seems to have replaced the cathedral in our culture," declares Gretchen Buggeln. "Irrespective of whether museums are regarded as sacred spaces, visitors often experience them as holy places and have personal encounters with religious objects, glimpses of the sublime, aesthetic revelations, or even an elevated sense of self-importance."

Rina Arya notes, "Religious visual culture parallels the approach of viewing contemporary art as evoking spirituality. Religious visual culture endorses the democratization of objects and imagery that dispenses with the sharp hierarchy in the history of art between high and low, or mass, art. When viewers talk about experiences of a spiritual kind, they are implying that there is a temporary alteration in their psychological state that involves the setting apart of that moment from the mundane, a making sacred. Another factor that needs to be taken into consideration is context. Spiritual experiences are no longer confined to religious buildings but can be found in a variety of secular spaces—the museum, art gallery, nature park—on a temporary or long-term basis. This involves the expansion of context where art works are exhibited, as well as the blurring of boundaries between the sacred and the secular."

"It is often said that art galleries today are the new cathedrals – places that people visit to replenish the spirit in a secular age. But for many centuries, cathedrals functioned in the manner of art galleries. Walk into any cathedral in Western Europe," Alastair Sooke continues, "and you will discover countless examples of beautiful art works, from intricate wooden carvings and metalwork to moving marble sculptures and exquisite painted altarpieces.

The artist and the art critics having risen in social prominence and have become artist advocates. In an industrial era in which the religious past was at best uncomfortable and to many it was quite abominable, the arts were a marvelous alternative. The arts fell easily into the hands of secular advocates. Each shocking new movement in art, from impressionism to rock & roll, became a proud boast for the advancement of culture without religion.

A part of the high place sought by and at least partially obtained by the arts community requires art to move

beyond its traditional confines and to usurp the realm of religion. As the spiritual leader, the arts must have their own theology to do this. Theology implies theologians, a priestly class of discoverers and explainers. Also required are shrines and sacred objects. Art critics and art historians are the redactors and theologians of the art world. Museums, monuments and show places serve as shrines and temples."

"When artists first disengaged from the control of patrons, there was a significant minority who clambered for a priestly function. While it might be a stretch of the imagination to suggest a priesthood, there is a sense in which the modern zeitgeist is being accurately reflected in the arts," claims Francesca Gavin.

With Mischief Aforethought: The Aesthetics of Black Humor

Much of Valentin Popov's thematic work is marked by a satirical streak and a healthy dose of its companion sensibility, black humor. Black humor is broadly defined as a comic style that makes light of subject matter that is generally considered taboo, especially with respect to subjects that are ordinarily considered serious or painful to examine. Comedians often use it as an instrument for exploring off-limits issues, thereby provoking discomfort and serious thought as well as amusement in their audience. Popular themes of the genre include death, disease, disability and violence. Black comedy differs from outright obscenity in that it lacks any intention of defying propriety. In obscene humor, shock and revulsion are key elements, while the active ingredient in black comedy or "sick" comedy is irony, or even fatalism. Whereas the term black comedy covers humor associated with many serious subjects, gallows humor, a philosophical cousin, tends to be used more specifically in relation to death, or situations that are reminiscent of dying. Black humor can occasionally be related to the grotesque genre. Sarcasm, skepticism and cynicism naturally attend the phenomenon, and irony is an intrinsic component.

Although black humor is not a new phenomenon, and instances in art and literature can be traced as far back as the ancient Greeks and Aristophanes, it was not until 1927 and 1935, respectively, that an essay by Sigmund Freud explicated black humor and its psychic functions as an instinctive coping mechanism for trauma and the poet and theoretician Andre Breton formally codified it. Breton, founder of Surrealism and the group's official leader, coined the term "black humor" and authored the now classic Anthology of Black Humor. Charter members of the historic Surrealist inner circle, in its heyday during the 1920s through 1940s, embraced black humor as a guiding principle.

Black humor has been employed by a wide array of writers down through the centuries. Andre Breton drew his chief inspiration for the formulation of his ideas concerning black humor from the writings of the Irish satirist Jonathan Swift. The tradition as a literary device has persisted to the present day as evidenced by novels, poems, stories, plays, and songs in which profound or horrific events are portrayed in a comic manner.

Among visual artists who have embraced black humor as a regular constituent must be included Giuseppe Archimboldo, Franz Messerschmidt, Honore Daumier, James Gillray, William Hogarth, George Grosz, and Donald Roller Wilson for their grotesque and exaggerated approach; Gustave Courbet with his compositions *The Desperate Man* and *The Origin of the World;* and Antoine Wiertz, whose lurid *Last Thoughts and Visions of a Decapitated Head, Hunger, Madness and Crime, The Suicide,* and *The Premature Burial* exemplify a shocking and macabre version; and Felicien Rops, for his blatantly blasphemous variants such as Calvary, in which the crucifixion of Christ is pornographically eroticized.

"The painting entitled *The Blessed Virgin Chastises the Infant Jesus Before Three Witnesses* is a controversial work by Max Ernst. This composition depicts the Christ child being spanked by his mother. In the Christian faith, Jesus is the representation of God on Earth. This means that Jesus was a perfect man who committed no sins. This painting shakes the foundations of this religion by portraying its most important symbol as an imperfect child who must be scolded and physically reprimanded for his misbehavior. This act of reprisal is also justified due to the usage of symbolism by depicting Mary's halo still over her head while the infant Christ's crown lies on the ground. He has thus fallen from grace and is instead a normal human and no longer a deity. This scene displays the dreamlike imagery which harkens back to that of de Chirico. Ernst provides this feeling in the ways that the building around the virgin is shaped. The house is shaped in non realistic ways and shown from different perspectives. Walls are drawn so that they appear to be at sharp angles that do not allow the viewer to see where exactly they are standing in the house. This element adds a sense of confusion which possesses a menacing quality as the painting is observed over time. The confusion added by the setting helps add to the unsettling subject of the painting."

The Virgin Spanking the Christ Child before Three Witnesses: Andre Breton, Paul Eluard, and the Painter, Max Ernst, 1926

Art historian Rina Arya notes that "a number of artists use religious images in ways that cause offense for the sole purpose of debunking religious tradition and flouting propriety. Francis Bacon is a special case. He was vehemently atheistic. In his career he used more than fifty images of crucifixions and popes, which were evidenced in the titles of works and symbols. Commentators have examined the significance that these symbols held for Bacon. He may have been atheistic, even antireligious, in his pronouncements, but his work involves much more than transgression. One plausible reading is that Bacon was commenting on a Godless world that had just experienced the atrocities of Auschwitz and Hiroshima, where the crucifixion indicates the violence of humanity and the pope languishes in a world in which he is redundant. The symbols of the Christian faith are mere mythological symbols of a belief system that is no longer tenable. Bacon was documenting the spiritual malaise of a humanity that has been made level with the animal in the absence of God.

"When contemporary artists tackle Christian subjects today, they often do so in an iconoclastic, ironic, disrespectful or subversive fashion. They employ shock doctrines and deliberately transgressive methods. Think of the Italian artist Maurizio Cattelan's satirical sculpture La Nona Ora, in which Pope John Paul II lies on a red carpet, crushed by a meteorite that has just plummeted from the heavens; or Piss Christ, a photograph by the American artist Andres Serrano, in which a small plastic crucifix is submerged in a glass of urine."

When Chris Ofili's painting *The Holy Virgin Mary* was exhibited in New York in 1999, the city's then-mayor, Rudolph Giuliani, took exception to the artist's vision of a black Madonna with a bare breast molded from elephant dung: 'The idea of having so-called works of art in which people are throwing elephant dung at a picture of the Virgin Mary is sick,' Giuliani said. In the 1990s, a number of "religious" works became the site of controversy in the Culture Wars. In 1999, New York City Mayor Rudolph Giuliani was outraged at the public

display of Chris Ofili's *The Holy Virgin Mary* because of what he deemed to be the unacceptable use of cutouts of female genitalia that surrounded the main image of the Virgin, and also the further fact that the Virgin's right breast had been fashioned out of elephant dung. He regarded this as being disrespectful to the holiness of the subject and unsuccessfully attempted to have it banned when the *Sensation* exhibition moved to the Brooklyn Museum in 1999. From another point of view, it could be argued that by showing graphic cutouts of images that we would not conventionally place next to the Blessed Virgin, Ofili is actually reinforcing her sanctity and virginity.

Sarah Lucas's tongue-in-cheek *Christ You Know It Ain't Easy* uses the figure of Christ, composed of cigarette butts, to provoke humor in what resembles an advertising slogan. A number of isolated cases of controversial artworks, however, go beyond irony and cause outcry. These are transgressive because they cross the boundaries of what is deemed acceptable to religious groups and lead to ramifications that include their banning or destruction. The sensationalist examples of transgression by Gilbert and George, particularly in their 2005 show *Sonofagod Pictures: Was Jesus Heterosexual* at the White Cube London, took an openly provocative stance, but there are other works that are carefully nuanced and, when looked at in the round, convey the complexity of religious expression.

Having relatively fewer constraints than artists in earlier centuries, and hence greater autonomy, contemporary artists have sometimes exploited religious symbols in ways that go against their traditional role to support faith, and are used instead ironically or blasphemously, in order, alternately, to critique and to provoke. Both inside and outside the contemporary art world, iconic images of Christ are summoned because of the degree of familiarity and connotations they represent."

Popov's *St. Batman and Ironic Icons* series fall within this category, whether intentionally or inadvertently, and cast him unavoidably in the role of artist as provocateur. Like his fellow aforementioned artists and like Joseph Beuys, who affected the trappings of religious ritual by adopting the role of shaman in his performances, Popov strives to bring about a subtle spiritual transformation in the spectator. And, as in the cover of the April 1999 issue of *New Yorker* magazine featuring the comic book character Plastic Man gawking at a distortion-rife Picasso painting, Popov achieves, with *Ironic Icons*, a perfect expression of postmodernism. Filtered through the "Esperanto of the eye," his vision fuses religion and mythology, Pre-Raphaelite atavism, the campy vocabulary of commercial advertising, and hagiographic solemnity to enshrine art's inexhaustible capacity for re-invention.

Rick Gilbert

142

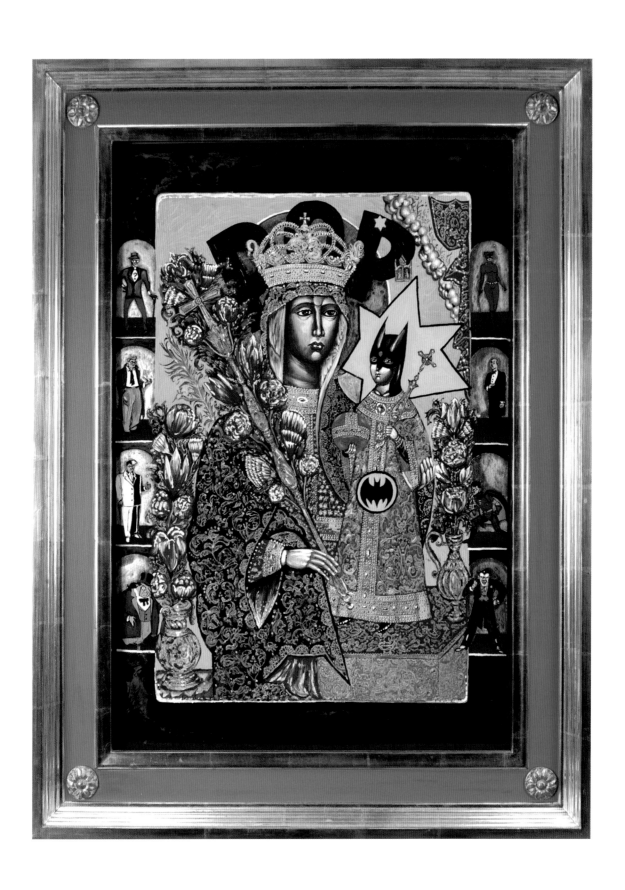

Pop St. Batman" oil on gilded aluminum 29"x23" 2012

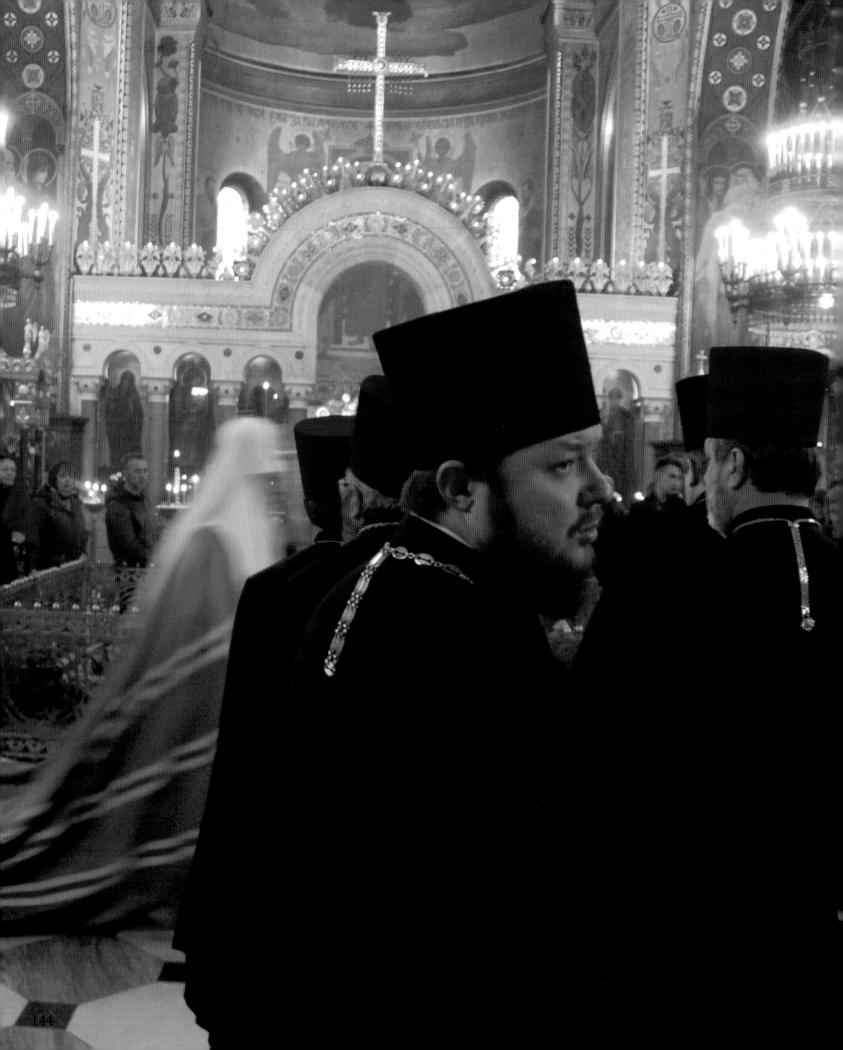

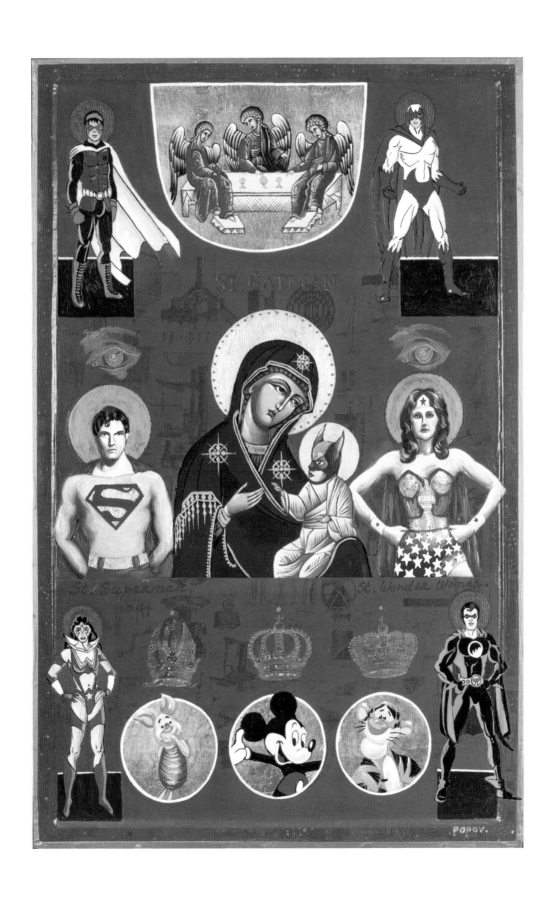

"St. Batman" oil on gilded wood block 23.5"x15" 2012

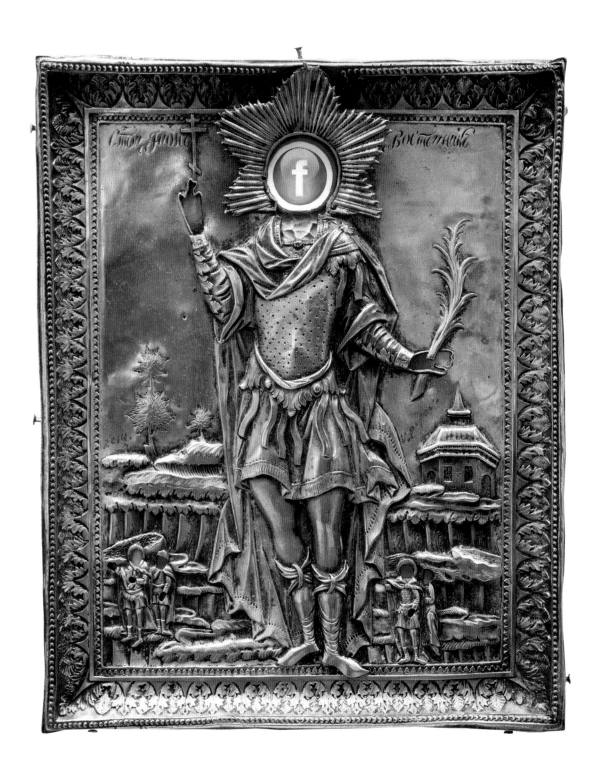

"Face Book" oil on a wood block, brass 19th century oclad 12"x10" 2010

146

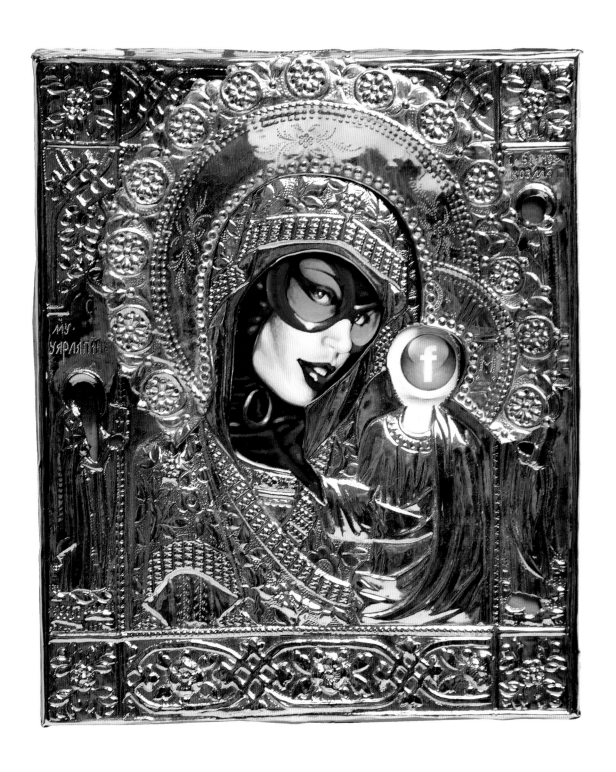

"Cat Woman and Face Book" oil on a wood block, gold plated 19th century oclad 12"x10" 2010

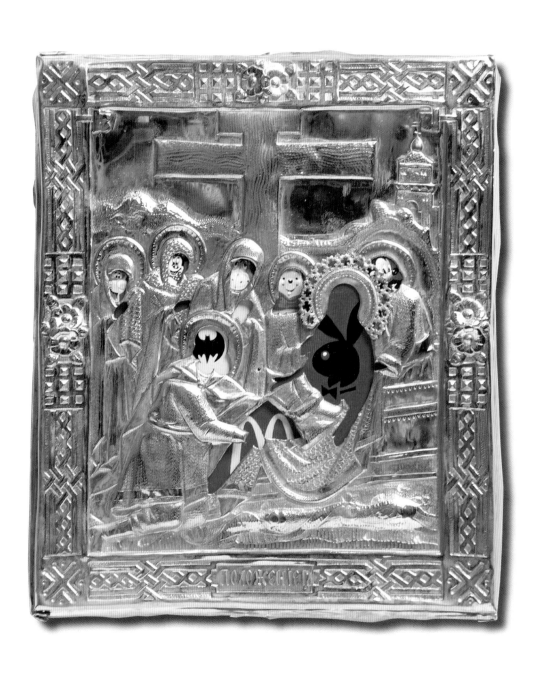

"Play Boy" oil on a wood block, gold plated 19th century oclad 12"x10" 2009

148

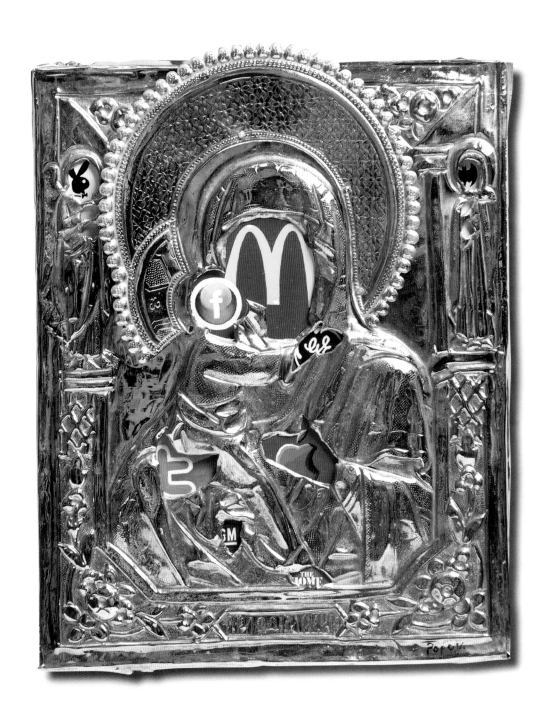

"Mary and Face Book" oil on a wood block, silver plated 19th century oclad 10"x8" 2010

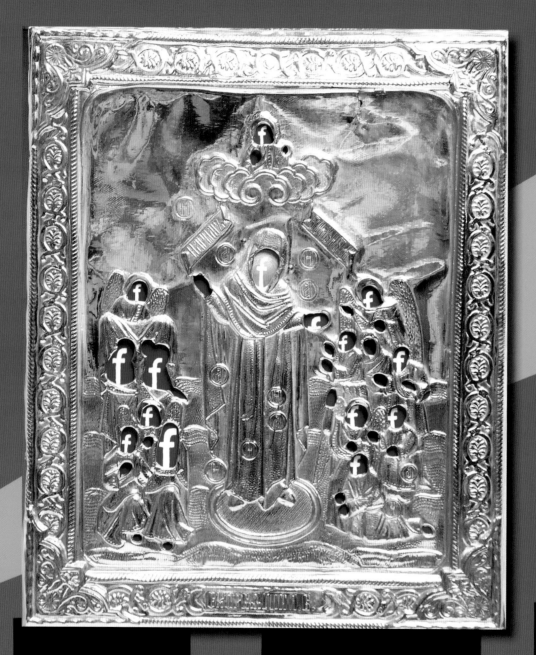

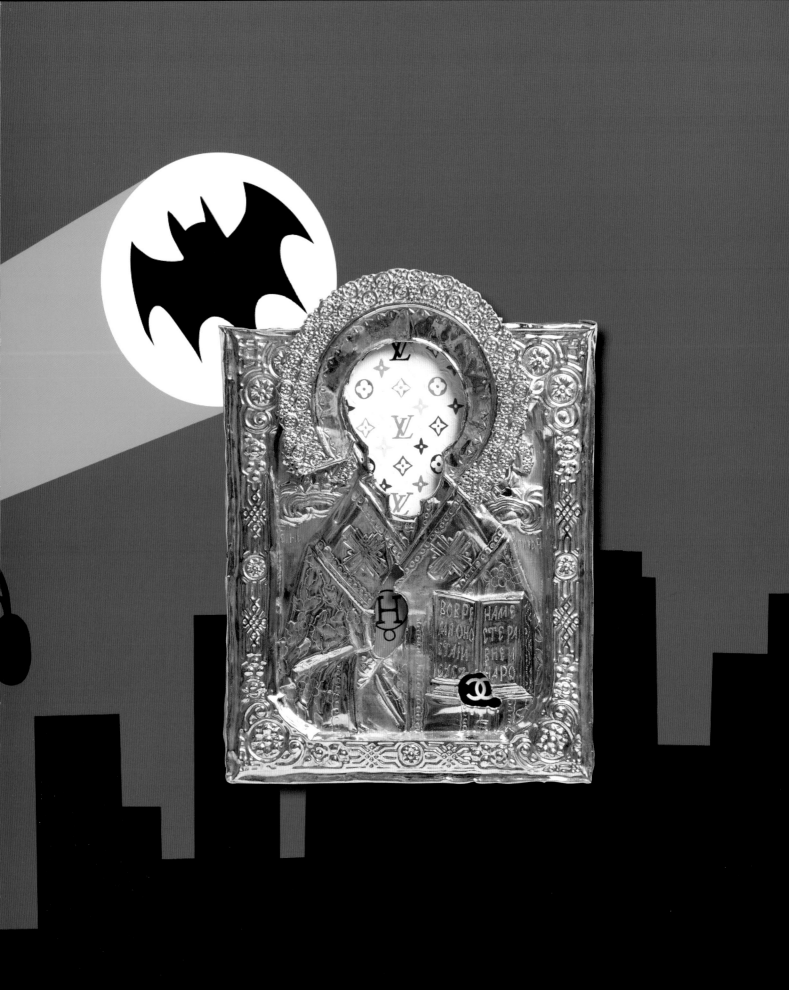

"Louis Vuitton" oil on a wood block, gold plated 19th century oclad 12"x10" 2010

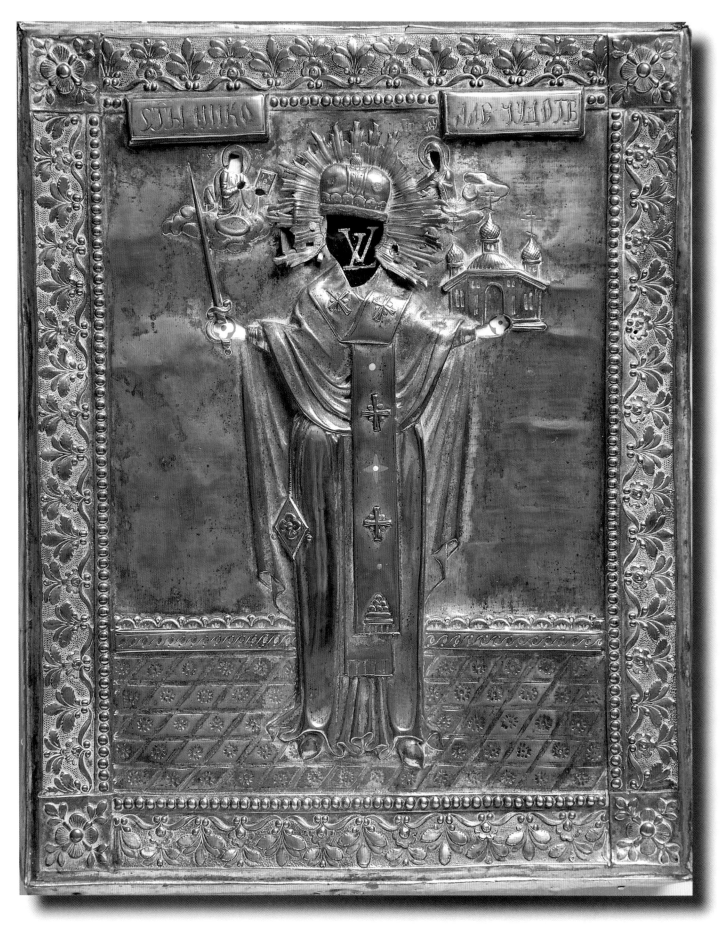

" LV " oil on a wood block, brass 19th century oclad 12"x10" 2010

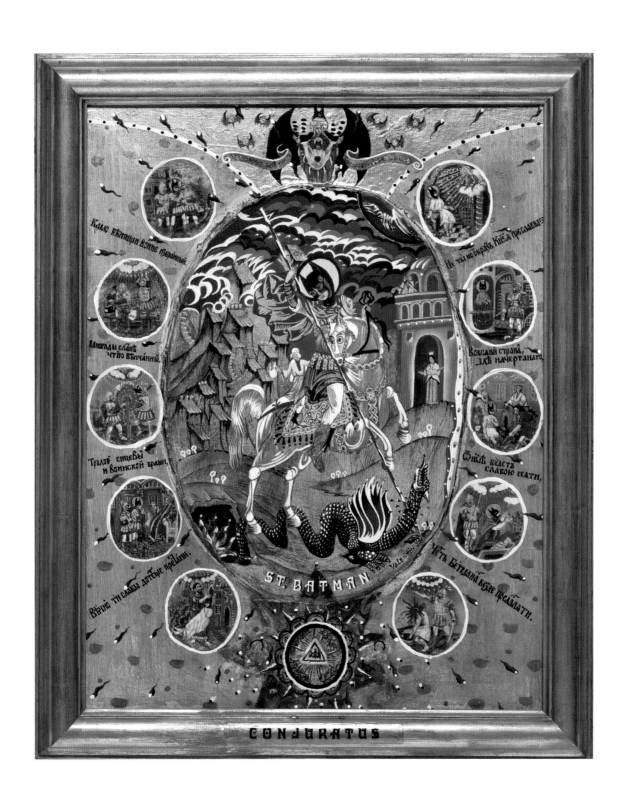

"Batman Icon (St. George)" oil on gilded wood block 28"x122" 1993

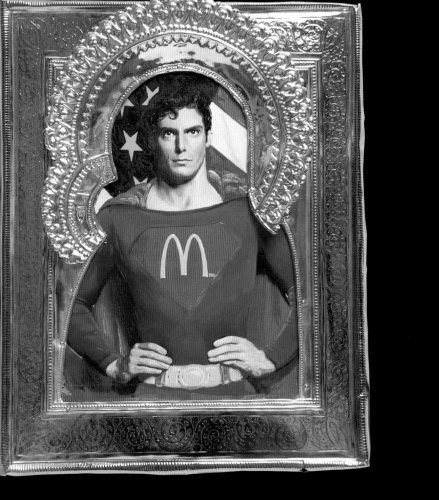

Valentin Popov

Valentin Popov, recently elected foreign member of the National Academy of Arts of Ukraine, is the classically-trained, transplanted-to-California Ukrainian who fathered Romantic Cynicism, a term for the attitude characterizing his elegant, conceptual-realist paintings treating sometimes tragic, sometimes comic, pop-existential themes in a lofty style reminiscent of the art of Renaissance allegorists and French Academicians. Popov consistently demonstrates the always-startling virtuosity of his trademark "etched-line" brushstroke and the richness and liquidity of a lush, ink-tinted palette. Apart from their undeniable poetry, Popov's compact-field monotypes and mock icons ooze radical technical refinement, while his large-scale, dramatic works pack sheer visceral punch. With his unique blend of technical mastery and ideological innovation, Popov is a distinctly satisfying artist whose work is hauntingly evocative. Popov, himself a product of traditional art education in the former Soviet Union, spent long years mastering conventions in the Academy of Art in Kiev. Equally expert at painting, etching, collage, photography, sculpture, and installation, Popov often mixes media within genres, and is as comfortable emulating Russian religious icons as he is contriving kitschy decorative imagery suitable for Liberace's dining room. Borrowing liberally from the greatest imagery in the classical canon, Popov practices a method of appropriation, adaptation, and transformation where he puts familiar images to unfamiliar uses or indulges in extremely novel exercises in technique. As a master engraver, he has done exquisite linocuts and monotypes based on classical literature and, as an extension of this skill, paints on aluminum using his brush as a stylus!

Popov's classical training has endowed him with tools and technical strengths often missing from the contemporary Western art scene, while American pop culture and the whole lineage of post 1920s avant-garde art proscribed in the former Soviet Union where he spent his formative years, but which he can now freely assimilate, has given him a vast playing field for intellectual and artistic development, and has enabled him to synthesize a unique vision of the old and the new, of the corny, sentimental, and moralistic and the campy, ironic, sneaky, and surreptitious. Perhaps an appropriate tag for this vision is "pop baroque," inasmuch as it fuses elements characteristic of both these widely disparate schools. Even though Russia was, during half of the twentieth century, isolated into a sort of aesthetic Galapagos, cut off from artistic developments in much of the rest of the world, artists like Valentin Popov have managed to evolve hybrid products unlike anything anyone else is doing. While fellow émigrés Komar and Melamid, using high-handed methods of presentation, mockingly glamorize or debunk past symbols of Soviet socialism, especially political personages, Popov brings to bear the same sort of technical virtuosity to create images which explore the psychology underlying this human need for leaders, martyrs, and heroes.

The postmodernist extraordinaire, Popov did not arrive at his formative maturity in a vacuum. As a young artist developing within the contradictory, multiple-personality art world which was the Ukraine during the Soviet era, he shared the frustrations and aspirations of disaffected "nonconformists" such as Komar and Melamid. He assimilated the influence of both classical realists like Ilya Repin and Vasily Vereschagin

and the Russian avant-garde. He sublimated in his consciousness the ubiquitous, state-sponsored, official propaganda art steeped in social realism, which bore an ironic similarity to the pop art of the West. Prior to the 1917 Revolution, some of Russia's most illustrious painters were attracted to proto-modernist European art movements such as Symbolism and Art Nouveau. In spite of the dominance of traditional realism as the standard approach to visual art for the preceding three hundred years, Russia at the dawn of the twentieth century was receptive to new intellectual and aesthetic trends then current in the rest of Europe, and nurtured several new movements of its own. There were the Miriskusniki, or members of the World of Art movement; the Peredvizhniki, or Wanderers; the Russian Symbolists, and such other transitional groups as the Blue Rose and The Jack of Diamonds, which straddled the gap between traditional realism and the incipient avant-garde.

At the other end of the spectrum was the Stroganov School, the last major Russian icon painting school, which thrived under the patronage of the fabulously wealthy Stroganov family of merchants in the sixteenth and seventeenth centuries. Stroganov School icons are noted for exquisite compactness, a refined palette frequently involving half-tints, and gold and silver finishes, dense layering, graphic precision, richly attired figures stilted in posture and gesture and fantastic landscapes. Neo-primitivism, partly in homage to the traditional art of the religious icon, would enjoy a vogue on the Russian art scene in the early years of the twentieth century.

From Peter the Great on, the tzars accumulated important works of Western art, which made the Western art tradition available for observation and study by Russian artists. These collections tended to be heavy on works from the Italian Renaissance and by Dutch Masters. By the eighteenth and early nineteenth centuries, Russia had well-developed traditions of its own both in portraiture, landscape, and historical painting. Though influenced by Romanticism, mainstream Russian painting in the mid-nineteenth century remained primarily a matter of classical realism. By the last decades of the century, Naturalist artists such as Repin and Vereschagin were in their prime. Even while Naturalism made its debut on the Russian cultural horizon, other work of the time exhibited the extreme ornamentality associated with the rococo and the baroque. In Russian art, the two tendencies were not necessarily mutually exclusive. Several waves of Symbolism rolled through Russia between the 1890s and World War I, carrying with them subtle intonations, abstruse allusions, minute attention to details, delicate shading and muted coloration, and the introduction of dreams as subject matter and as atmospheric adjunct. In 1890, the Russian Symbolist painter Mikhail Vrubel, achieved fame with a large mosaic-like canvas titled Seated Demon, then went mad while working on the sinister Demon Downcast in 1902. Other Symbolist painters include Victor Borisov-Musatov, a follower of Puvis de Chavannes; Mikhail Nesterov, who painted religious subjects from medieval Russian history; Mstislav Dobuzhinsky, with his "urbanistic phantasms"; and Nicholas Roerich, whose paintings have been described as hermetic, or esoteric. Non-representational art programs such as Rayonism and ZORVED emerged between the turn of the century and the revolutionary period, along with the similarly non-objective and experimental Cubo-Futurism, Suprematism, Constructivism and VKLUTEMAS (an acronym for Higher Art and Technical Studios, a progressive, state-sponsored applied arts institute). Among the noted artists affiliated with these schools and movements were Archipenko, Malevich, Tatlin, Pevsner, Gabo, Rodchenko, Lissitzky, Moholy-Nagy, and Schlemmer. The Russian avant-garde thrived from approximately twenty years before

the Revolution to approximately twenty years after and was at its height during the period subsequent to the Revolution until 1932. By 1920, however, government authority was controlling art. In 1934, social realism became state policy. Rebellion against the classical heritage of academism and formalism became moot or, worse, objectionable, in the face of the Bolshevik mandate for a propagandistic, ideology-driven social realism intended to extol the utopian ideals associated with the Revolution. The Soviet period saw the overwhelming ascendancy of social realism, which often involved "staging" of subject or composition, as the only "acceptable" aesthetic. "Non-conformist" and "dissident" art, which gave vent to personal sensibility or ideological statement not in accord with state doctrine, was not only not sanctioned, but was denied any possibility of public exhibition, and was sometimes even censored or destroyed. Finally, during the late Soviet period and immediate aftermath, the satiric mock social realism of Komar and Melamid had its advent.

It was around this time that Popov, the very personification of pluralism, stepped in. In light of his thorough immersion in Russian, European, and American traditions, both before and after the modernist phase, and considering his classical training at the Art Institute of Kiev in the Republic of the Ukraine, where he absorbed within the hallowed halls of that august academy the techniques of art history's greats, it is perhaps little wonder that Popov would come to adopt a regimen of appropriation, quotation, and paraphrase while perfecting not a style but an entire spectrum of styles which have enjoyed a broad-based exhibition history in museums and galleries the world over. Nothing less than protean in his ability to execute exemplary works of encyclopedic variety, Popov, through his skirting of social realism by taking up the illustration of classical literature, his westward migration, absorption of modernism, and eventual assimilation of its chief tenets and methodologies, traces his influences to samovar and coke can both. He is a child of many muses and a chimera of transitions and trajectories; among Popovian moods and tenses must be listed neo-transcendentalism, enigmatism and pop surrealism, photorealism, poetic realism, eclectic formalism, luminism, tonalism, constructivism, intimism, allegorical and cryptic narrative, woozyism, and chromatic absolutism. Profoundly versatile, Popov is a fine arts polymath who employs a visual syntax which ranges across huge portions of the aesthetic atlas; two dominant strains in the Russian sensibility, satire and mysticism, overshadow his work; his imagery often borrows from symbolism and the occult, while his choice of motifs may extend to conceits from the Pattern and Decoration movement; his themes include reflective surfaces, dreams, secret messages and closet narratives, figuration, light, entelechy of objects, natural elements and natural systems, exaltation and epiphany. Popov might be said to incarnate Salvador Dali's assertion that "everything which does not stem from tradition is plagiarism."

Rick Gilbert

IRONIC
ICONS

OF VALENTIN POPOV
12, 2017 - MARCH 19, 2017

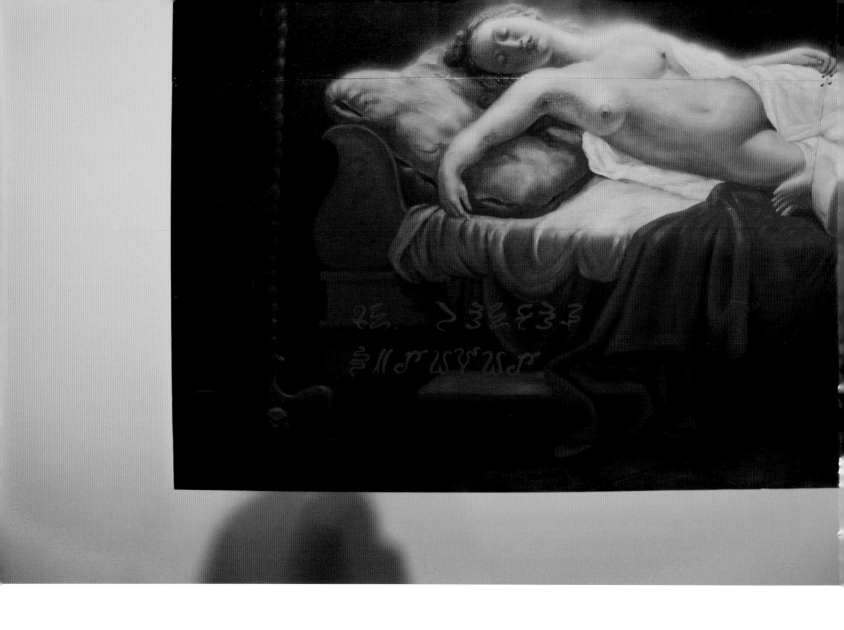

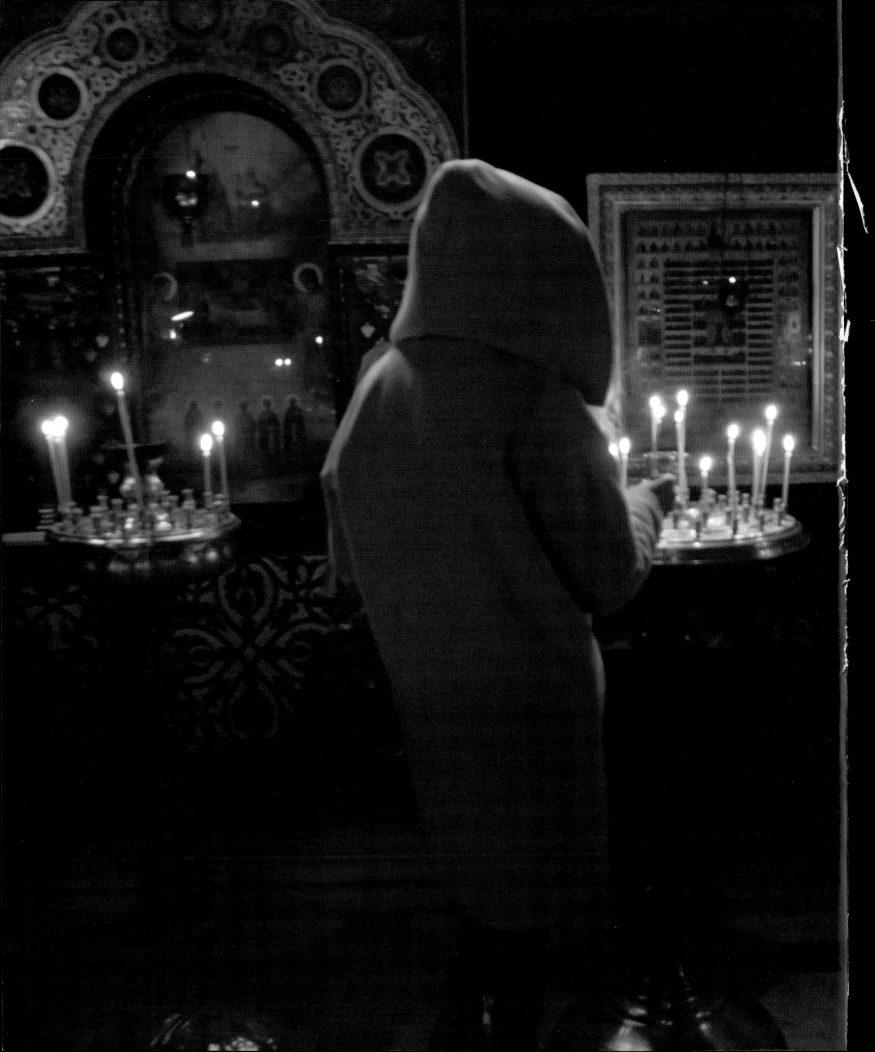

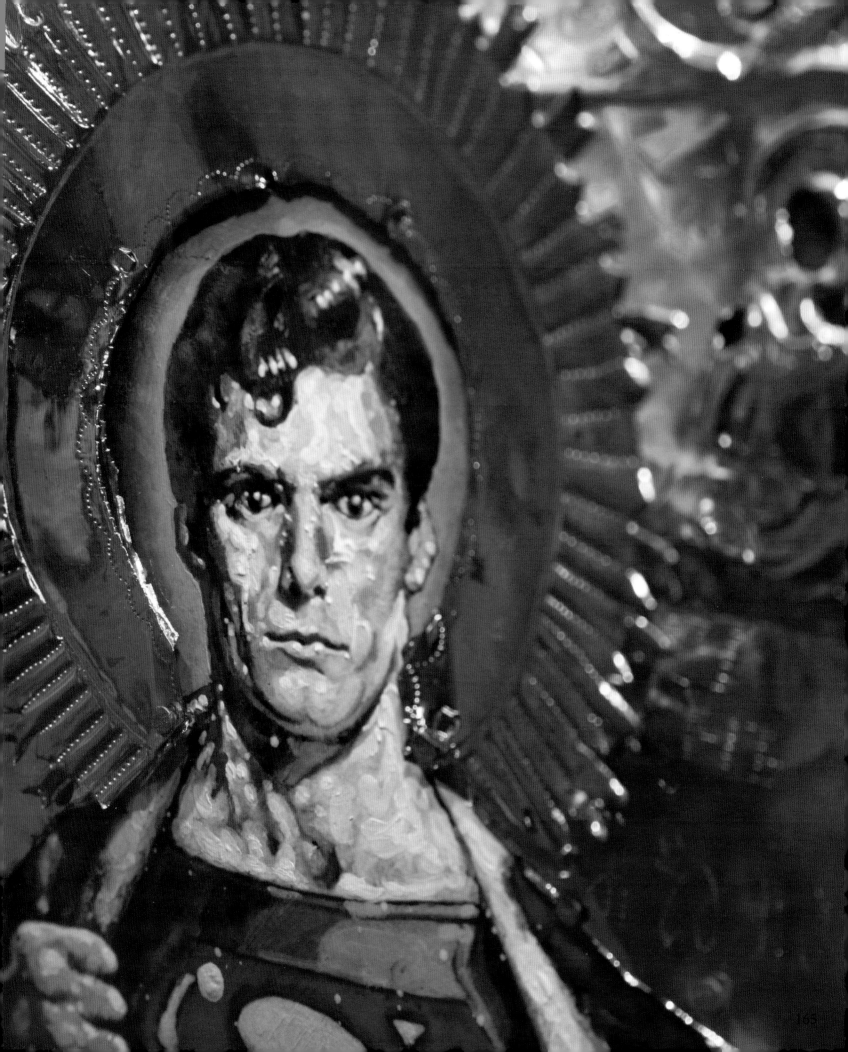

VALENTIN POPOV

Oakland, CA
Born 1956 in Kiev, Ukraine

EDUCATION:
1974-80 Kiev State Arts Institute (Academy of Fine Art of Ukraine)
1969-74 Kiev State School of Art, Kiev, Ukraine
Foreign Member of National Academy of Arts of Ukraine

SOLO EXHIBITIONS:
2020 "Mopdern Mixmaster" Sonoma Valley Museum of Art, CA
2020 "Retrospective Journey"College os Marin Fine Arts Gallery
 Kentfield, CA
2019 "Collected Moments" Modernism West, San Francisco, CA
2018 "FACE"-national academy of fine art of Ukraine, Kiev, Ukraine
2017 "Ironic Icons" solo show at Long Beach Museum of Art. Long Beach, CA
2016 "Super Hero" (Mel Ramos, Valentin Popov, Victor Sydorenko),
 National Academy of Fine Arts of Ukraine, Kiev, Ukraine
2016 Long Sharp Gallery "Reflections" Indianapolis, Indiana
2013 De Saisset Museum "FACE" University of Santa Clara, California
2013 Imago Galleries "Water" Palm Desert, California
2011 Thom Andriola Gallery, "61,8%", Houston, Texas
2010 Modernism Gallery, "In the Water", San Francisco, California
2009 Thom Andriola Gallety, "Vision & Light", Houston, Texas
2008 Modernism Gallery, "Then & Now", San Francisco, California
2006 Modernism West, "25 Years", San Francisco, California
2006 Alycia Duckler Gallery, Portland, Oregon
2006 Modernism West, San Francisco, California
2005 Alycia Duckler Gallery, Portland, Oregon
2004 Modernism Gallery, San Francisco, California
2004 Lora D Art Gallery, Chicago, Illinois
2003 Lora D Art Gallery, Chicago, Illinois
2003 Elezabeth Rice Fine Art, Sarassota, Florida
2002 "Val Pop" Huntington Beach Art Center, Huntington Beach, California
2002 Dee Pree Museum "Go Dutch", Holland, Michigan
2001 Robert Berman Gallery, Bergamot Station, Santa Monica, California
2000 National Museum of Ukrainian Art, Kiev, Ukraine
2000 Pasquale Iannetti Art Gallery, "Collage & Sculpture", San Francisco, California
1999 Pasquale Iannetti Art Gallery, "Rembrandt-Not Rembrandt",
 San Francisco, California
1998 Diane Nelson Fine Art, "Rembrandt-Not Rembrandt", Laguna Beach, California
1997 Kismet Gallery, "Crucifixion of St. Batman", San Jose, California
1996 Mimi Ferzt Gallery, "Romantic Cynicism", New York, New York
1996 Kismet Gallery, "Romantic Cynicism", San Jose, California
1995 Mimi Ferzt Gallery, "Torrents of Spring", New York, New York
1994 De Saisset Museum, "Romantic Cynicism", Santa Clara, California
1994 Mimi Ferzt Gallery, "Rembrandt Collage", New York, New York
1993 Mimi Ferzt Gallery, "Popov + Popov", New York, New York
1993 Pasquale Iannetti Art Gallery, "Weird Monotypes", San Francisco, California
1992 Kentler International Drawing Space, New York, New York
1991 Warner Roberts Gallery, Palo Alto, California
1991 Arts Council of San Mateo, Belmont, California
1991 Central Exhibition Space of Association of Fine Arts of Ukraine, Kiev, Ukraine
1990 University of California, Berkeley, California
1990 Allport Gallery, San Francisco, California
1988 Kisgaleria, Pecs, Hungary

GROUP EXHIBITIONS:
2019 "Fantasies and Fears" Piramid Gallery, Istanbul, Turkey
2019 Collected Moments, Modernism West, San Francisco, California
2016 "Super Hero" (Mel Ramos, Valentin Popov,Victor Sydorenko)
2015-2016 Long Sharp Gallery, Indianapolis, IN
2014 Imago Galleries, Palm Desert, CA
2012 New gallery, Houston, TX
2012 Modernism Gallery, Summer selection
2001 Imago galleries , Palm Desert, California
2005 Sandy Carson Gallery, Denver, Colorado
2004 Modernism Gallery, "25-th Anniversary Show", San Francisco, California

2003 Modernism Gallery, San Francisco, California
2002 Robert Berman Gallery, Santa Monica, California
1998 Mimi Ferzt Gallery, "Group show", New York, New York
1998 Diane Nelson Fine Art, "Contingent Reality", Laguna Beach, California
1997 Kismet Gallery, "Group show", San Jose, California
1997 Mimi Ferzt Gallery, "Group show", New York, New York
1996 Mimi Ferzt Gallery, "Group show", New York, New York
1995 Mimi Ferzt Gallery, "Group show", New York, New York
1994 Mimi Ferzt Gallery, "Ascending Angels", New York, New York
1994 De Saisset Museum, "Ideal Landscapes", Santa Clara, California
1994 Kala Institute, "Fellowship Award", Berkeley, California
1994 Aurobora Press,"The Figure", San Francisco, California
1993 California Museum of Arts & Crafts, "Icons in Contemporary Art",
 San Francisco, California
1993 J. Claramunt Gallery, "Sacrifice", New York, New York
1993 Olga Dollar Gallery, "Miniatures", San Francisco, California
1993 Ruth Benjamin Fine Art, "The Spirit Within", Napa Valley, California
1993 Davidson Galleries, "Group Show", Seattle, Washington
1993 Smith Anderson Gallery, "The Black & White Show", Palo Alto, California
1992 Emeryville 6th Annual Exhibition, Emeryville, California
1992 Pasquale Ianetti Gallery, "12 Contemporary Artists", San Francisco, California
1992 One Market Plaza "Russian Art at Home & Abroad", San Francisco, California
1991 "Coming to America-World View Point", West Cal Bank, San Mateo, California
1991 Ayzenberg Gallery, Los Angeles, California
1990 International Gallery, Minneapolis, Minnesota
1990 Warner Roberts Gallery, Palo Alto, California
1990 Olga Dollar Gallery, "Summer Selection", San Francisco, California
1988 "Contemporary Art of the Ukraine", Ukraine Institute of America,
 New York, New York
1988 "Modern Art of the Ukraine", New Jersey Institute of Technology,
 Newark, New Jersey
1988 Crane Club Gallery, New York, New York

PUBLIC COLLECTIONS:

Metropolitan Museum of Art, New York, New York
New York Public Library, New York, New York
De Saisset Museum, Santa Clara, California
Zimmerli Art Museum, Rutgers University, New Brunswick, New Jersey
Museum of Russian-American History of Alaska, Sitka, Alaska
Duke University Museum of Art, Durham, North Carolina
Logan Collection, Fine Arts Museums of San Francisco, California
Fine Arts Museums of San Francisco, California
Achenbach Foundation for Graphic Arts, San Francisco, California
National Museum of Ukrainian Art, Kiev, Ukraine
Iris & Gerald Cantor Center for Visual Art, Stanford, California
Minneapolis Institute of Art, Minneapolis, Minnesota
Haggerty Museum of Art, Marquette University, Milwaukee, Wisconsin
Schow Foundation, San Marino, California
Philadelphia Museum of Art, PA
Harvey S. Firestone Library, Prinston University, Princeton, New Jersey
Spencer Museum of Art, The University of Kansas, Lawrence, Kansas
University of Michigan Museum of Art, Ann Arbor, Michigan
Yele University Art Museum, New Haven, Connecticut
Flint Institute of Arts, Flint, Michigan
Berkeley Art Museum, Berkeley, California
Stanford University Libraries, Department of Special Collections, Stanford, California

ARTIST IN RESIDENCE:
1992 Fellowship of KALA Institute, Berkeley, California
1991 Smith-Anderson Printshop, Palo Alto, California
1990 Djerassi Foundation, Woodside, California
1980 1983-89 Senezh Artists' Residence, Moscow, Russia
1980-82, 84-86 Republic Sednev Artists' Residence, Chernigov, Ukraine

AWARDS:
2015 Foreign Member of Academy of Fine Arts of Ukraine
1988 Silver Medal, Academy of the USSR
1984-1986 Grant from the Association of Fine Arts of the USSR
1981-1984 Grant from Academy of Art of the USSR

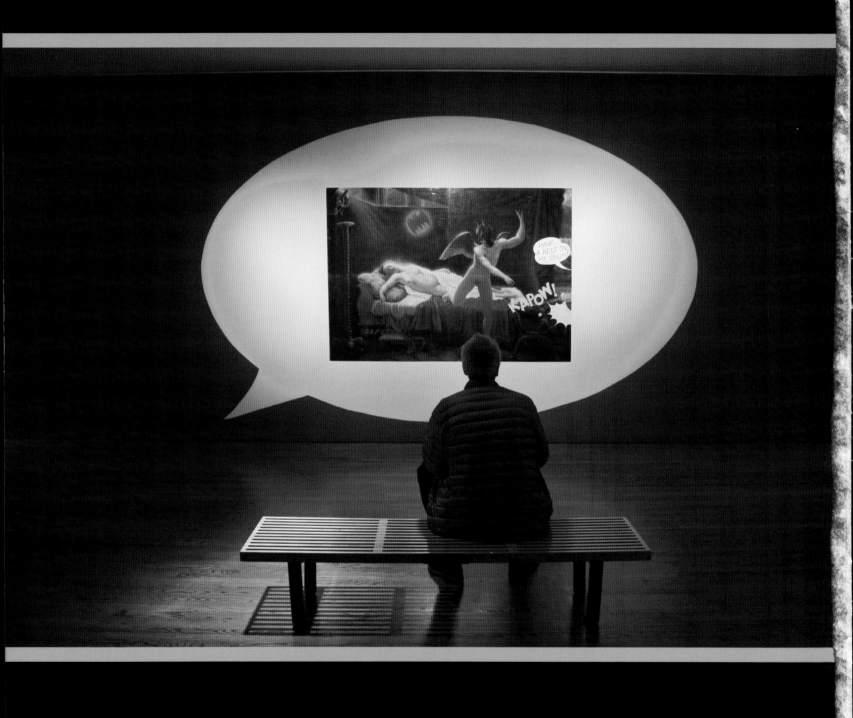